David Bellamy's
Complete Guide to Watercolour Painting

First published in Great Britain in paperback 2011

Search Press Limited
Wellwood, North Farm Road,
Tunbridge Wells, Kent TN2 3DR

Reprinted 2011

First published in Great Britain in hardback 2009

Illustrations and text copyright © David Bellamy 2009

David Bellamy asserts the moral right to be identified as the author of
this work

Photographs by Debbie Patterson at Search Press Studio

Photographs and design copyright © Search Press Ltd. 2009

ISBN: 978-1-84448-734-9

The Publishers and author can accept no responsibility for any
consequences arising from the information, advice or instructions given
in this publication.

Suppliers
If you have difficulty in obtaining any of the materials and equipment
mentioned in this book, then please visit the Search Press website for
details of suppliers:
www.searchpress.com

Publisher's note
All the step-by-step photographs in this book feature the author,
David Bellamy, demonstrating his watercolour painting techniques.
No models have been used.

You are invited to visit the author's website:
www.davidbellamy.co.uk

Acknowledgements

I would like to thank Roz Dace and Sophie Kersey at Search Press
for their kind help and support in producing the book, and
Debbie Patterson for her excellent photography. Also Sarah Clark of
Winsor & Newton, Katherine Allaway, and not least
Jenny Keal who helped me with scanning images, checking my
literary excesses, some photography and much more.

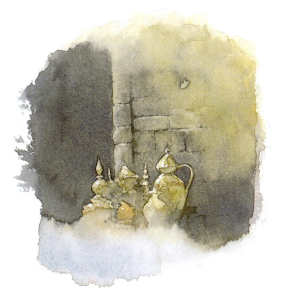

Page 1
The Old Barrow
180 x 230mm (7 x 9in)
*Muck is one of the easiest things to paint in watercolour and I loved
the way the barrow got lost in it. The barrow and white chickens
were first covered with masking fluid to retain the hard, light edges,
and the masking fluid was only taken off once all that muck had
been painted.*

Page 3
Tollesbury, Essex
380 x 510mm (15 x 20in)
*In order to emphasise the ragged cloud edges, the dry brush sparkle
on the water and the rough grasses, I used a Rough paper for this
watercolour.*

Opposite
Cottage Below Blencathra
160 x 240mm (6¼ x 9½in)
This painting also appears in the Buildings chapter on page 90.

Printed in Malaysia

Contents

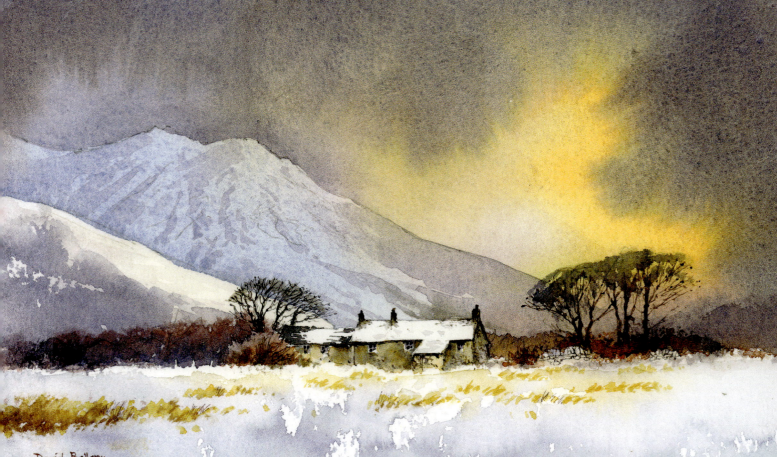

David Bellamy

Introduction

Many beginners to watercolour painting try just one discipline, whether landscape, flowers, still life or whatever, and as a result can miss out on subject matter for which they may be better suited. In this book my aim is not only to give you a good grounding in these main areas, but also to encourage you to try subjects with which you are not familiar. This approach, like a foundation course, will show you the benefits of working in a variety of disciplines before you pick the one on which you wish to concentrate, allowing you to experiment in areas that perhaps you have never considered, and providing you with an alternative when you slip into a rut and are not sure what to paint next.

You may want to skip the chapters until you reach your favourite, which is fine, but you will be surprised how much one discipline can affect the others. Take still life for instance. Many find it boring, but in that chapter you will find out that you can use it in your areas of special interest, how it can enhance travel journals, or how it can help you to work out textures or the effects of candlelight. Flowers and plants, while superb subjects in themselves, can truly enhance many a landscape: how thrilling it can be to come across the vibrant colours of some small flower fighting for its existence in one of the world's most savage places. Those who shy away from including figures in their landscape, town or seaside paintings will find ways to tackle this, but will also learn how to take figures as subjects in their own right. Whether they are from some far-flung part of the globe, or our nearest and dearest, people always make fascinating and delightful subjects.

You may be one of those 'beginners' who admit to being in their fifteenth year of painting. If you are in this intermediate stage, you will find much to interest you here: the prospect of trying new subject matter perhaps; or looking at your favourite subject from a new perspective such as including still life studies in your landscapes; or maybe trying a method of painting water that you had not come across before. If you are having trouble with your foregrounds then you may well benefit from the feature aimed at making this area of working easier to handle.

Those who take up painting often remark how they now view the world in a new light and see so much more than they did before they started. If this is uncharted territory for you, then exciting adventures into the world of watercolour lay ahead. Once you learn how to paint, it is with you for all time.

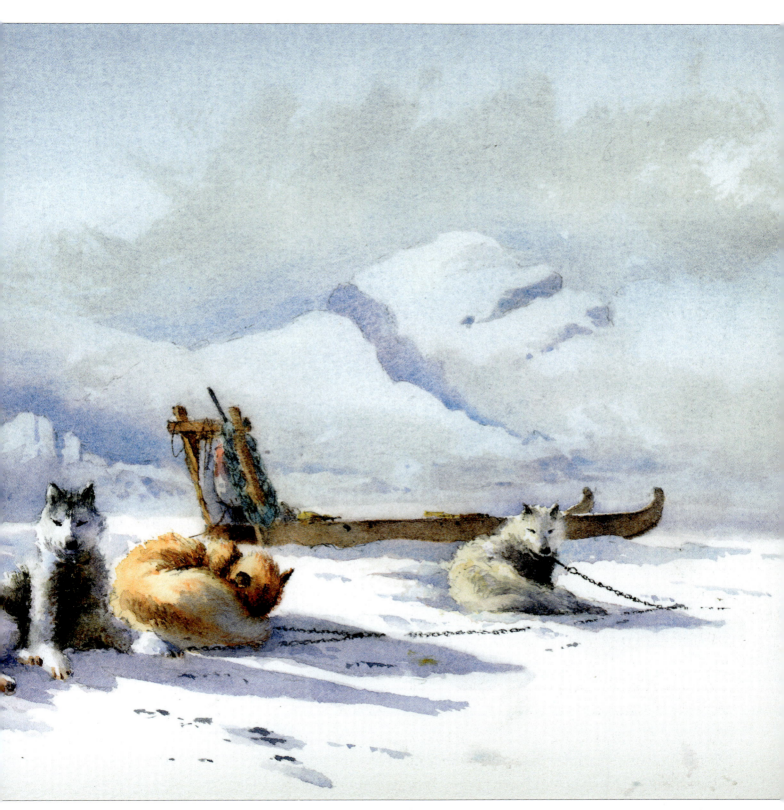

Greenland Huskies Resting
200 x 250mm (7⁷⁄₈ x 9⁷⁄₈in)
Where the huskies appear as white as the snow, I have used shadows to show their form.

Materials

Never has it been so easy to buy a lot of art materials that you do not need. If you are new to watercolours, surrounding yourself with all manner of brushes and a wide range of paints is more likely to make life difficult rather than easier. Initially buy only a few well-chosen brushes and watercolours, and get to know how they work for you before gradually building up a set that really suits your purpose.

Paper and sketchbooks

Watercolour paper can be obtained in imperial-sized sheets, various pads, and blocks that are glued all round the four edges to avoid having to stretch the paper. Mostly it comes in weights of 190gsm (90lb), 300gsm (140lb), 425gsm (200lb) or 640gsm (300lb), with some manufacturers having a more extended range. The 640gsm (300lb) paper is as heavy as cardboard and expensive; the 190gsm (90lb) version rather flimsy and prone to cockle alarmingly. If you choose 300gsm (140lb) paper, you will most likely need to stretch it before painting unless you work on really small sizes, so many people find the 425gsm (200lb) paper the ideal weight as it does not need stretching unless you are painting larger works.

A selection of watercolour papers.

Papers generally come in three types of surface: Rough, Hot-pressed and Not or Cold-pressed. Beginners can find the smooth, Hot-pressed paper a challenge to work on, as the washes dry more quickly. It is excellent for fine detail, but you may find it best to leave this surface until you are more experienced. A Rough surface is extremely effective for creating textures and ragged edges, or with the dry brush technique for laying a broken wash, although it does not enhance fine detail. The most popular paper is the Not surface, which falls between the other two types in degree of smoothness. It is a good idea to try out paper from several manufacturers to work out which suits you best. Most of the paintings in this book are done on Bockingford, with many on Saunders Waterford.

I generally use A4 and A5 hardback sketchbooks with cartridge paper and wire-bound ones with watercolour paper.

Brushes

While there are now many excellent examples of brushes with synthetic filament on the market, the finest brushes for watercolour are those with natural hair. Top of the tree are the Kolinsky sable variety, which boast a really fine tip, a large belly to hold copious amounts of paint, and the ability to spring back into shape and not lie limp after one brush stroke. A good compromise, if you find sables too expensive, is to buy a brush of mixed sable and synthetic hairs. Large squirrel-hair mops make lovely wash brushes, although they are prone to losing the occasional hair.

You do not need many brushes to start out. A large squirrel mop for the washes, a no. 7 or 8 round, a no. 4 round, a no. 1 rigger and a 13mm (½in) flat brush is quite adequate. Later a no. 10 or 12 round and a no. 6 round would be useful additions. More specialised brushes for certain applications, such as a fan brush or an angled flat can also help on occasion, but are not essential. A fan brush can at times be effective in depicting falling rain or water dropping down a waterfall, and an angled flat for painting diagonal strokes across a roof, for example as demonstrated on page 15.

If you use the masking fluid method for creating highlights, you will need a small brush for this, but it is best to use an old one as the masking fluid can affect it badly. Alternatively it may be worth getting a cheap synthetic brush – a no. 1 or 2 round or rigger for this purpose.

Take care of your brushes and they will last well. Wash them out with clean water after use. Another reason for doing this is because any residue of paint left in the brush from previous use can badly affect any washes the next time you use the brush. Remember that if you leave them standing in a pot of water, they will end up a rather odd shape after a while and will be totally useless for their task.

Paints

Watercolour paints can be bought in tubes, pans and half-pans. I normally use half-pans for out of doors sketching, but for the larger studio paintings, tube colours are essential as one can quickly mix large washes. My box of twelve half-pans is supplemented by a number of colours in tubes when on expedition or travelling abroad.

Choice of colours is up to the individual, my own being fairly traditional with a sprinkling of modern pigments. I always work with artists' quality paints as they are more powerful and finely ground, but of course the students' variety are cheaper and there is less difference in quality with the earth colours, for example. In this book you will see my basic palette of a number of colours continually appearing, with just the odd new one creeping in here and there. It is best not to buy all these colours in one go. I recommend that you get the basic colours as shown in the first box, and learn how to mix them and how they react, only adding new colours from the second box when you are ready to extend your range.

To this list I would add white gouache, a very opaque white with tremendous covering power. It is far more effective than the Chinese white so often found in boxed sets, and excellent for those little white splashes you often need in a painting.

All the paints shown here have excellent permanence. Beware of any fugitive colours as these will quickly fade. Study the manufacturers' labels and leaflets to see which pigments fall into these categories. These will also tell you if the colour is transparent, opaque or falls between the two, a feature of the paints that we will cover later in the book.

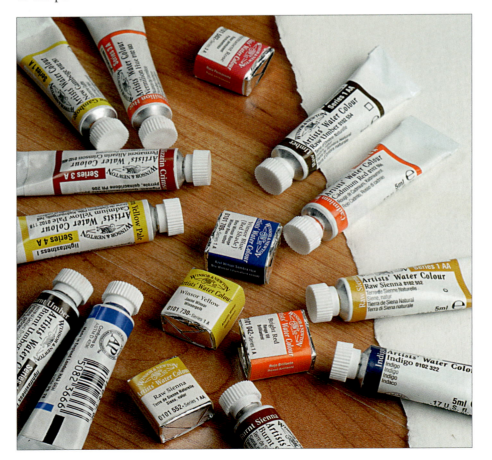

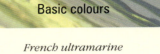

Basic colours

French ultramarine

Burnt umber

Cadmium yellow pale

Cadmium red

Cobalt blue

Winsor blue or phthalo blue

Alizarin crimson or quinacridone red

New gamboge

Light red

Yellow ochre or raw sienna

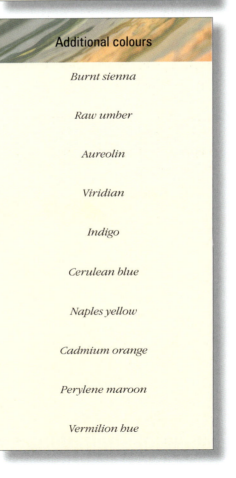

Additional colours

Burnt sienna

Raw umber

Aureolin

Viridian

Indigo

Cerulean blue

Naples yellow

Cadmium orange

Perylene maroon

Vermilion hue

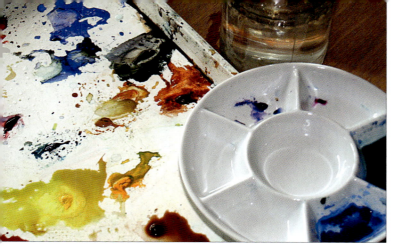

Palettes

Palettes of course are vital. You need a large one on which you can lay out the colours you are using, many of which will be for small areas of detail, and some for slightly larger areas. Another palette with deep wells is needed for mixing up pools of colour for the main washes. Many artists prefer to use a saucer, butcher's tray or large plate, and so long as they are white and do not affect the way you see the colours, these are perfectly fine. For a large wash, the whole saucer would be needed, but for small detail, many mixes can be made on a dinner plate.

A large butcher's tray is excellent for mixing up small amounts for detailed work, while a palette with deep wells is necessary to mix up large pools of colour for washes.

Other materials

Other items you will need include at least one drawing board, a selection of pencils from 2B to 4B, a putty eraser, a soft sponge, at least one large water pot, masking fluid and a scalpel. You need a knife for sharpening pencils and while one with a fine point will do, a scalpel works best for scratching out highlights on the paper. Also useful are bulldog clips, an old toothbrush for spattering, paper tissues and rags. A plant spray is useful to speed up the accurate mixing of colours and occasionally for spraying over a damp wash to create a speckled effect. If you intend stretching paper, then a roll of gummed tape will be needed.

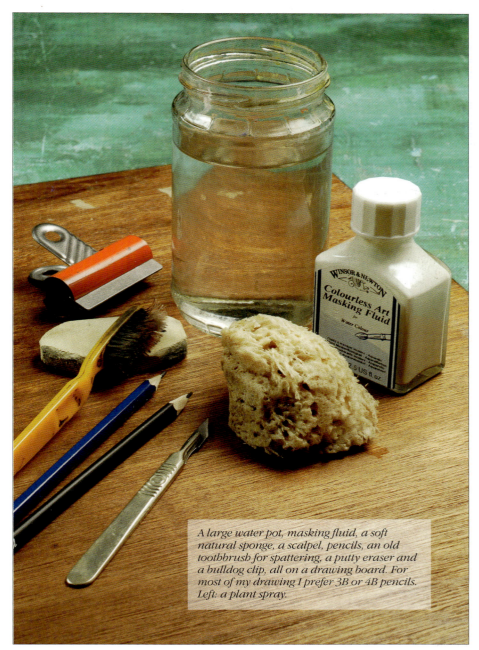

A large water pot, masking fluid, a soft natural sponge, a scalpel, pencils, an old toothbrush for spattering, a putty eraser and a bulldog clip, all on a drawing board. For most of my drawing I prefer 3B or 4B pencils. Left: a plant spray.

11

Basic techniques

Mixing paints

The ability to mix and lay a watercolour wash properly is fundamental to good practice. Many students fail to use sufficient water in their mixes, with the result that the wash will not flow properly and messy brush marks develop. Naturally, the colours need to be strong enough to achieve the desired result, and this is something that can only come with experience. As watercolour has an annoying habit of becoming lighter when it dries, this experience is even more necessary, especially as the pigments vary considerably in degree of lightening.

Taking either a palette with a deep well or a white saucer, squeeze out a generous blob of paint into the well and add water – you can do this with the brush, a pipette, or as I do with a plant spray, which is quick and offers good control over the amount of water. Mix it well, using a large round brush, until it forms a pool of colour. Be especially careful with certain pigments like cobalt blue, which form blobs, as if you do not notice them, they will create strong, unwelcome lines across your wash. If you are using pans, then you need to work the colour into a liquid pool in the well, and build it up: this usually takes longer than using tubes. It is a good idea to use an old brush for all this mixing, as it wears down the point of a brush.

Before applying any wash to the paper, it is vital to test it on scrap paper, not just to ascertain if you have achieved the right colour, but to see if the strength of tone is what you want and the fluidity is fine. You may find you need to adjust the colour or tonal strength, or perhaps more water is needed to get the wash to flow. If you are working on fine detail, you need to twirl the brush on the scrap paper to achieve a fine point before working on the detailed part.

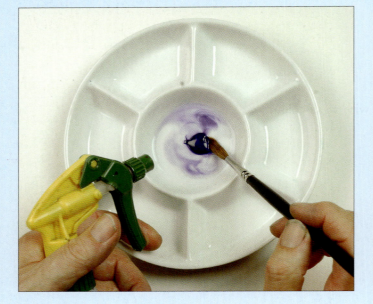

1 Put a blob of watercolour paint (here ultramarine violet) in the mixing well of your palette and give it a quick spray with water from your plant spray.

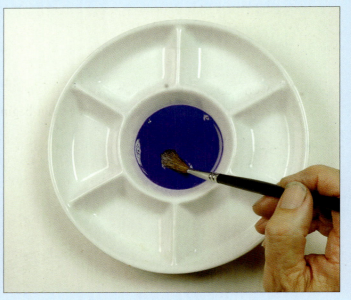

2 Spray more water and mix with an old brush until the paint reaches the consistency you need.

Applying a wash

Depending on the size of the wash, always use the largest brush you are comfortable with, because the fewer the strokes, the better the wash will appear. A large mop or round brush works best. Many artists lay their washes with a wide flat brush, which can work well, but these can make tramlines across the paper, caused by the sharp corners. If you first wet the area where you intend to lay the wash, this will give you a lovely smooth wash, but make sure you use absolutely clean water with an absolutely clean brush. This, of course, will dilute the wash a little so you need to make it slightly stronger than you want the finished wash to appear. Where you wish to create hard edges within the wash area, it is not practicable to wet the paper first, however.

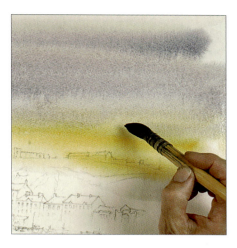

LAYING A FLAT WASH ON DRY PAPER

I have used Rough paper and a squirrel mop brush. Load the brush with a generous amount of paint and work across the paper with horizontal strokes, slightly overlapping. Keep the wash flowing down the paper with the board propped up at a slight angle, sloping towards you.

The finished wash.

LAYING A FLAT WASH ON WET PAPER

1 Wet the area with clean water and the squirrel mop brush. Apply the colour.

2 Use a smaller, clean, damp brush to remove the bead of paint from the bottom of the wash.

LAYING A GRADUATED WASH

This can be done on dry or wet paper as above, but begin with weak colour on the brush, strengthening the colour before applying the next horizontal stroke (or every other stroke, depending on how quickly you wish the wash to become darker). Alternatively you can start with the darker wash then weaken the colour with water as you move down the paper.

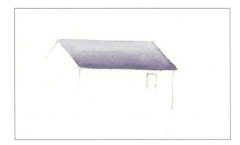

This shows a typical application where a graduated wash is more effective than a flat one. First the roof wash is laid, graduating from light to dark.

When the wash has dried, the surrounding features are added. If the roof were dark all over, its outline at the top would be lost in the dark trees.

LAYING A VARIEGATED WASH

The secret with running different colours into each other is to work quickly while the surface is wet. Lay out and mix all the colours you intend using before you begin laying the first wash on the paper. Ugly cauliflower effects are caused either by running a wet wash into an area that is already drying, or leaving pools of colour un-mopped at the bottom of a wash. These will seep up into the drying areas, and a similar effect occurs if the board lies flat on the table, so keep the board at an angle of between twenty and thirty degrees. Should these cauliflowers start forming, leave them well alone. Once they are completely dry, gently sponge them with clean water and in most cases they will simply fade away.

1 For this little scene I have drawn the houses on the skyline first. Paint a wash over the whole sky area with Naples yellow.

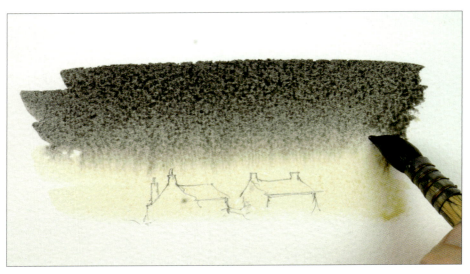

2 While the yellow wash is still wet, paint a mix of ultramarine and burnt umber at the top of the sky.

PAINTING OVER A DRY WASH

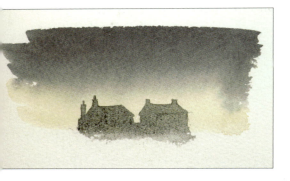

3 When the sky is dry, take the no. 7 brush and paint in the houses with the mix you used for the upper part of the sky.

WORKING INTO WET PAINT

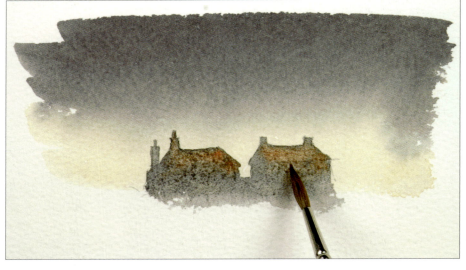

4 To add interest to the houses, drop in light red immediately over the roofs while the houses are still wet.

Brush techniques

Whether painting a large wash or making small calligraphic strokes, how you handle the brush is important. There are a variety of brushes suitable for watercolour painting, and we will now take a look at their characteristics.

DRY BRUSH

This is known as the dry brush technique, although the brush is damp rather than dry. The paint should lay damp on the brush, not wet as with a wash, and is then dragged across the surface. The rougher the paper, the more effective the result will be. Experiment with different brushes and paper.

DRAWING WITH A RIGGER

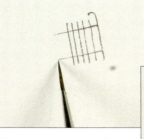

Here the rigger is used to paint metal railings.

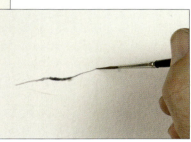

Here, differing pressure is used throughout one stroke of the rigger, varying the line.

LIFTING OUT A LINE

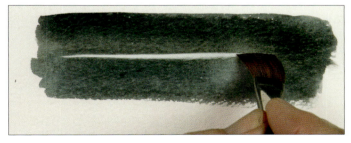

Paint a wash. When it is starting to dry, use a clean, damp, flat brush to lift out a line, working sideways with the brush.

CREATING A RAGGED EDGE

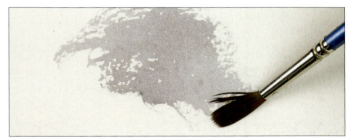

Use the side of a round brush on Rough paper to create a ragged edge.

USING AN ANGLED FLAT BRUSH

1 To create a corrugated roof, load an angled flat brush with cadmium red on one side and cerulean blue on the other. Splay the hairs a little and paint angled strokes as shown to create a corrugated shed roof.

2 Paint the lower part of the shed with a no. 7 round brush and yellow ochre.

3 Mix a strong green and paint round the edge of the shed.

Creating and retaining white

When you are working on white watercolour paper, this is the lightest tone available to you, so it makes sense to retain the whiteness where needed. This requires careful thought as it is so easy to paint over these areas without thinking. White paper left untouched can provide you with unrivalled highlights and enliven a painting with hardly any effort. Throughout the book are examples of white features created by working paint around them, thus describing them by what we call negative painting. An excellent example of this is the fork on page 36. Here we look at other ways of retaining white, and also creating them by various means.

USING MASKING FLUID

Masking fluid is a popular way of retaining white, but not all papers take kindly to it, so before using it for the first time on a painting, test it out on a piece of the paper. Apply the fluid on to dry paper before any painting and allow it to dry before laying any washes over it. Once all the washes are dry and you have finished that part of the painting, the fluid, which has become a rubbery solution, can be rubbed off with a finger or eraser. Note that if you leave it on overnight, it may be more difficult to remove. Immediately after using masking fluid the brush should be washed thoroughly in soapy water, as the fluid can quickly ruin the hairs.

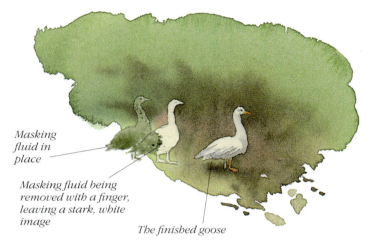

Masking fluid in place

Masking fluid being removed with a finger, leaving a stark, white image

The finished goose

WHITE GOUACHE

Gouache is an opaque medium and should be applied over watercolour. Do not dilute white gouache much, otherwise it will lose its covering power. Most of the time I apply it straight out of the tube using just a damp brush. It is also effectively applied with a toothbrush spatter.

SCRATCHING OUT

Scratching with a scalpel or knife should be left to the final moments of the painting, as it will look ugly if colour is washed over the scratch. It has infinite possible uses and is often used as a last resort when other attempts to create a highlight have failed.

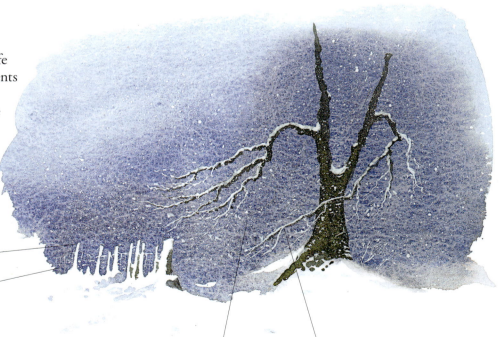

Fence posts achieved with masking fluid

Pig wire scratched out with a scalpel after masking fluid removed from fence posts

White gouache used with a toothbrush to spatter the falling snow and on a rigger to create the branches and twigs once the main wash and tree had dried

WAX RESIST

Wax resist can be achieved with a candle or wax crayon and is less controlled than the other methods of creating whites. It does have a lovely spontaneous feel that enhances certain subjects, a good example of which can be found on the dead leaves on page 33.

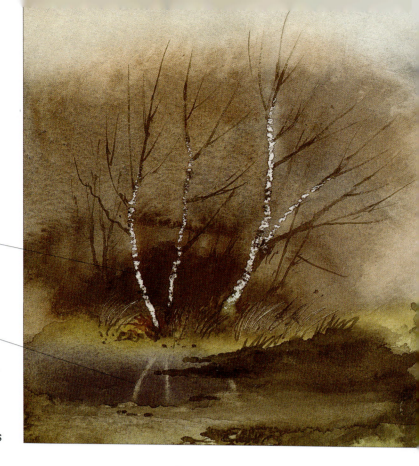

Birch trunks defined by rubbing a white candle down the paper before applying any paint

Light reflections lifted out with a damp brush

Using a white candle to create birch trunks

LIFTING OUT

This can be done with paper tissues, kitchen paper or a damp brush. Depending on how wet the surface is, you may need to repeat the process a few times. A sponge can be useful for softening off areas and edges, and can also be used with a stencil or a length of card to produce sharp edges, lines and shapes.

Lifting out, stencil and scratching out techniques

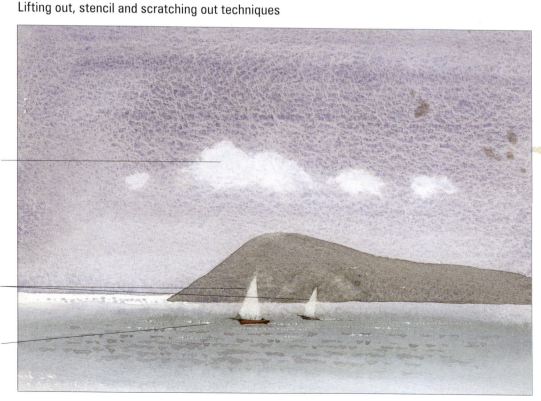

Clouds lifted out with a paper tissue while the wash was wet

Sails lifted out with a damp sponge when the painting was completely dry, while holding two straight-edged pieces of card in place as a stencil. The sponge was rubbed downwards and excess water was dabbed off with a paper tissue.

Wave crests scratched out with a scalpel

Painting a simple scene

We now look at how to paint a simple landscape in stages, beginning with the lightest colours and gradually working in the darker features. In this way we make the most of watercolour. Before you start, make sure the board is sloping towards you at a gentle angle of about twenty degrees, so that washes flow to the bottom and do not collect in puddles to create nasty marks on the paper.

YOU WILL NEED

425gsm (200lb) Not paper
Pencil and eraser
Colours: Naples yellow, yellow ochre, cadmium yellow pale, Winsor blue (red shade), cadmium red, raw umber, burnt umber, French ultramarine, light red
Brushes: squirrel mop, no. 4 round, no. 7 round, no. 1 rigger

1 Draw the scene.

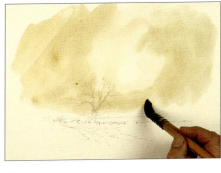

2 Use the squirrel mop to paint a wash of Naples yellow in the sky area, leaving an area of white paper just above and to the right of the tree. Drop in yellow ochre in places for variation while the sky wash is still wet.

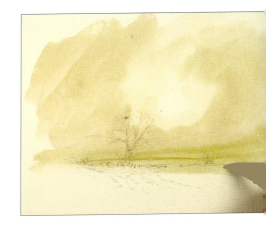

3 While it is still wet, bring the wash down just over the horizon, and mix in cadmium yellow pale.

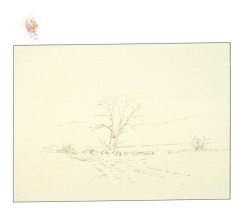

4 Still painting into the wet wash, paint yellow ochre at the bottom of the painting, leaving patches of white paper. Allow to dry.

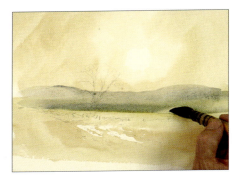

5 Mix Winsor blue (red shade) with a little cadmium red and use the squirrel mop to paint the distant hills.

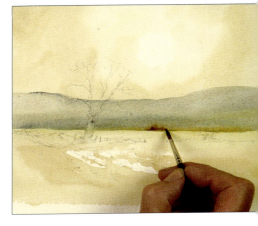

6 While the hills are wet, take the no. 4 brush and paint raw umber across the bottom of the hills to vary the colour. Drop in a little burnt umber wet into wet.

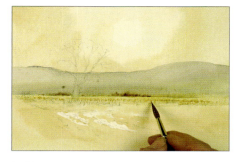

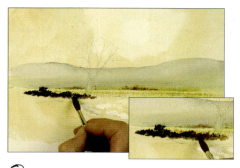

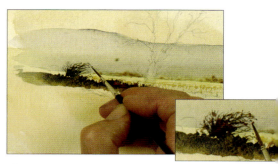

7 Pick up raw umber on the no. 7 brush and drag the brush on its side over the distant field to create texture with the dry brush technique. Here I dabbed in a few blobs of raw umber at the edge of the dry brush passage.

8 Use the tip of the no. 7 brush to paint a low hedgerow with burnt umber and a touch of ultramarine. Drop in yellow ochre at the bottom to soften it into the grass, then drop in light red.

9 While the hedgerow is still wet, use the rigger brush to draw fine details of branchwork. Drop in a little light red.

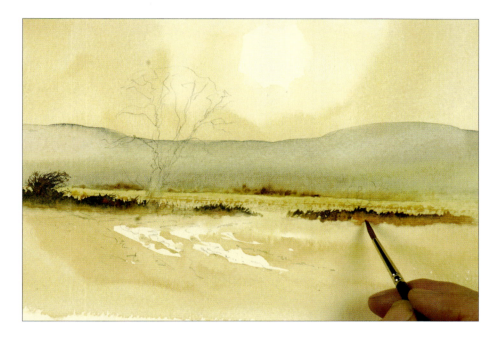

10 Use the no. 4 brush to paint the hedgerow on the right-hand side as in step 8, and drop in yellow ochre and then light red.

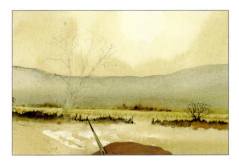

11 Change to the rigger and paint the finer details of trees in the hedge with the burnt umber and ultramarine mix. Paint the fence posts in the same way.

12 Change to the no. 4 brush and paint the trunk and branches of the tree. Drop in yellow ochre.

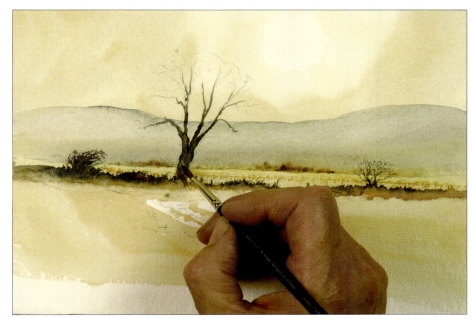

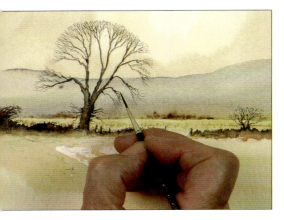

13 Change to the rigger brush and extend the branches and fine twigwork with the burnt umber and ultramarine mix. Apply less pressure the further out you go from the trunk.

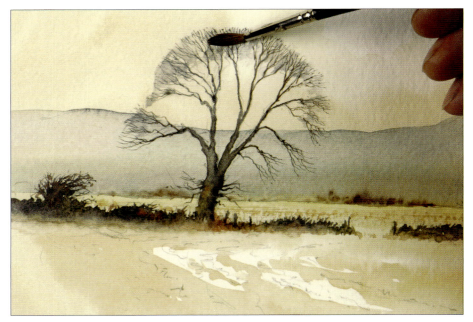

14 Mix a light wash of ultramarine and burnt umber and with the side of the no. 4 brush, apply it to the fine twigwork, working inwards from the extremities.

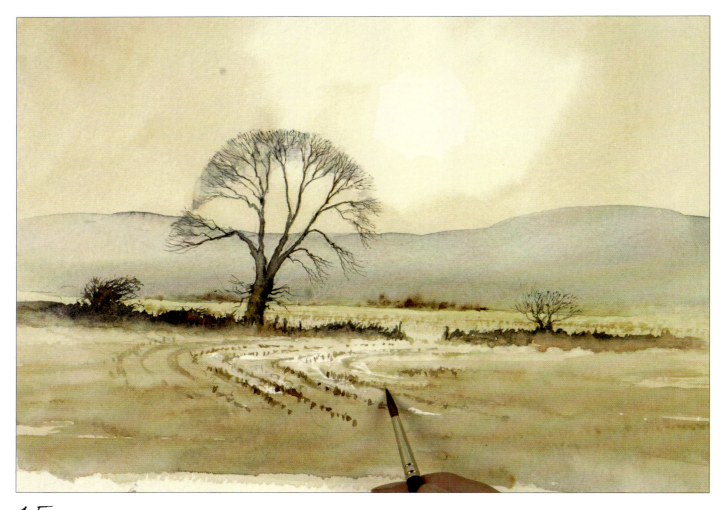

15 Use the no. 4 brush and raw umber to paint more stubble details and the tractor tracks in the foreground. Change to the no. 7 brush and paint a wash of raw umber over the foreground.

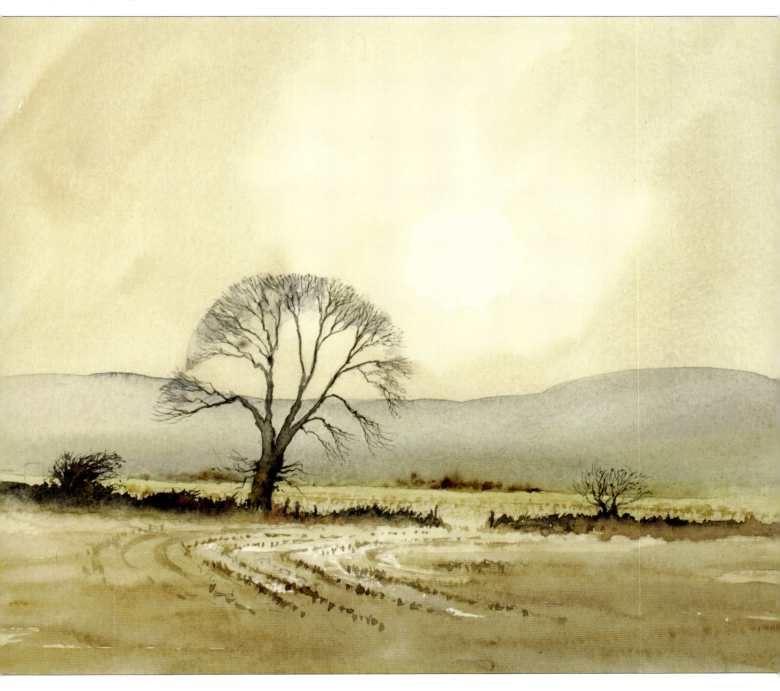

The finished painting.

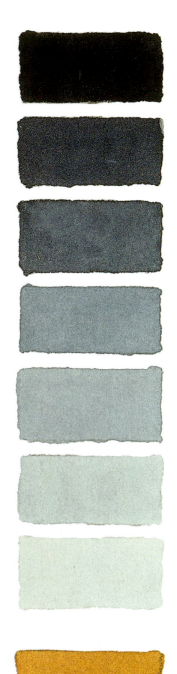

Understanding tone

Tone, or value as it is sometimes called, will help define the various shapes and passages of your painting, eliminating the need to describe everything with a line. The tonal scales diagram (left) shows you how different colours can vary in the range of tones they can produce.

Coping with tonal ranges and mixing various colours causes the beginner real problems in tackling their early watercolours. An extremely useful exercise in the understanding of tones is to paint a number of monochrome watercolours, as you can forget about colour and simply concentrate on getting the tones right. Choose a dark colour such as burnt umber or indigo so that you have a wide range of tonal possibilities. Working in this way also alerts you to the power of unity: too many different colours in a painting can ruin any sense of unity. At the same time, you are learning how to apply paint in washes and in detail without too many complications. Begin with small, uncomplicated subjects such as the pots shown opposite, tackling more ambitious ones only when you feel more confident.

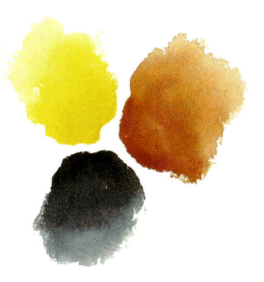

Tones of three different colours. Clockwise from top let: aureolin, burnt sienna and indigo.

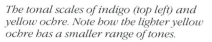

The tonal scales of indigo (top left) and yellow ochre. Note how the lighter yellow ochre has a smaller range of tones.

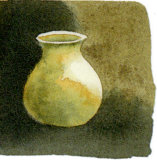

Using tone to show form

In the left-hand pot a dark outline has been drawn to show the shape, but as such lines do not exist, the artist needs to use tone for this purpose as shown in the right-hand pot. While some artists use outlines in a stylised form of expression, we should first learn to depict objects in a natural manner.

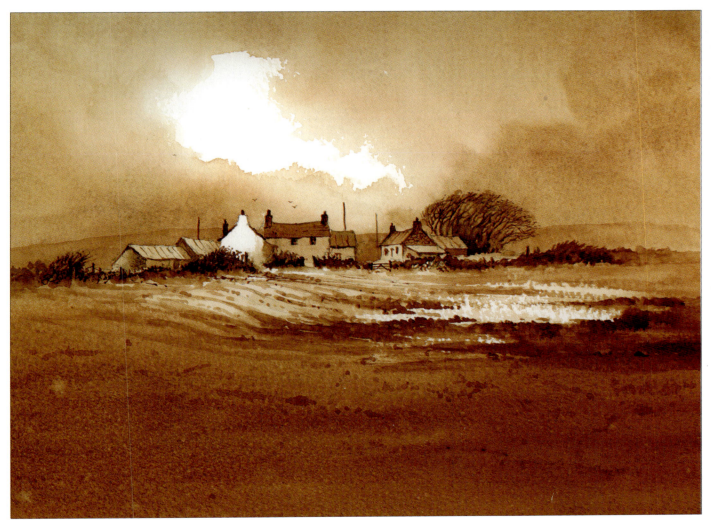

Trelerw
180 x 250mm (7 x 9⅞in)

This monochrome painting was achieved with just burnt umber, a colour which has a wide range of tones, thus making it suitable for a painting. It was painted in the normal way, starting with the lightest tones, then gradually working in the darker ones, leaving the very darkest until the end. Note how important the white areas are – this is simply where the white paper has been left untouched.

Using colour

To be presented with a box of twenty-four watercolours can be daunting. It is far better to choose a few good colours and get to know them first, then gradually expand your colour range as you progress. Here are some exercises.

Lightening and darkening colours

In order to lighten a colour, we simply add water. Attempting to mix in white will simply produce a milky, opaque appearance. To darken a colour beyond its strongest tone, mix it with a similar but darker colour, as with the cadmium red example. Try this using a medium-toned blue such as cobalt or French ultramarine, darkening it with deeper blues such as indigo.

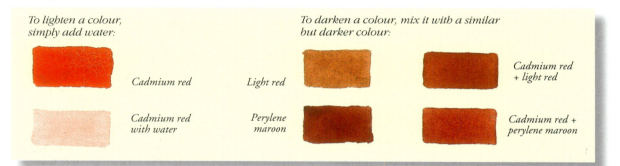

To lighten a colour, simply add water:

Cadmium red

Cadmium red with water

To darken a colour, mix it with a similar but darker colour:

Light red

Perylene maroon

Cadmium red + light red

Cadmium red + perylene maroon

Mixing greens

In my examples of mixtures for producing greens, I have deliberately chosen some effective colours for landscape work, and it is helpful to have a chart of your favourite mixes laid out in a similar way. While you may be tempted to stick with some of these combinations, I do recommend that you explore a wider range of mixtures as I have done with the greys opposite, where you can try out every possible combination. Naturally space has limited the number of colour mixes that can be shown here, but this will start you off on your colour exploration.

Below are examples with various colours, achieved with equivalent amounts of each colour. By adding more of one colour, greater variation can be created. A third colour can be added (see opposite), but take care as the more colours in the mix, the greater the tendency towards mud.

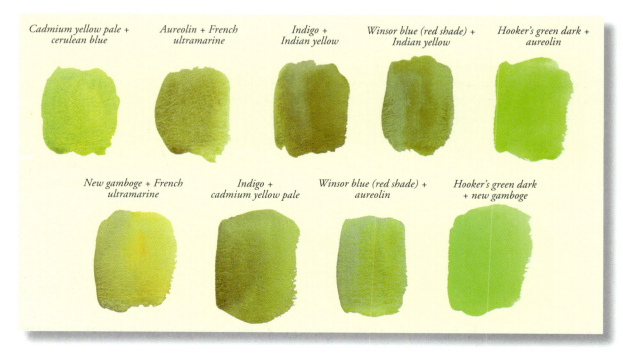

Cadmium yellow pale + cerulean blue

Aureolin + French ultramarine

Indigo + Indian yellow

Winsor blue (red shade) + Indian yellow

Hooker's green dark + aureolin

New gamboge + French ultramarine

Indigo + cadmium yellow pale

Winsor blue (red shade) + aureolin

Hooker's green dark + new gamboge

Mixing greys

It pays to explore colour mixing in a more methodical way to ascertain how various combinations work, and which suit your particular needs best. A good range of greys, for example, is useful whatever your subject matter, and being able to produce a warm or cool grey quickly, with various tones and tints is vital. In the chart below I have mixed similar strengths of colour in each case, but you can take this further by using more of one colour. Try all these combinations. Your results may vary because perhaps you mixed more of one colour, or in some cases different manufacturers' paints differ, even when they have the same name. I have used Winsor and Newton artists' quality paints. Once you have exhausted the greys, do the same chart for greens, mixing not just yellows and blues, but other possibilities such as raw umber and blues, raw sienna and blues and even yellow with black – although I hardly ever use black as it is such a dead colour. Mix ready-made greens with other colours: viridian is not an attractive colour in my eyes, but it mixes well to produce more acceptable landscape greens. Before applying any of these mixtures to your painting, test them on white paper.

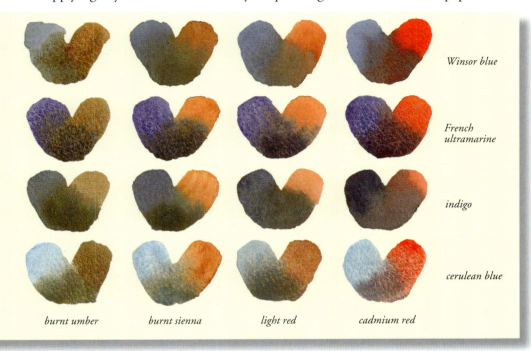

Winsor blue

French ultramarine

indigo

cerulean blue

burnt umber *burnt sienna* *light red* *cadmium red*

This selection of greys is done in a more systematic manner which I recommend you carry out when trying to achieve a variety of mixes, whether it is greys, greens, purples or anything else that you wish to produce. In the first vertical column, burnt umber has been mixed each time with a different blue on each horizontal row. Continue with further colours to see which greys suit you best, which mixtures produce warmer greys and which produce cooler greys. Annotate your charts.

Mixing colours for foliage

I rarely mix more than two colours, and then the third colour is normally only a slight amount, but I do like dropping colours into an already laid wash while it is still wet. This is a powerful method of creating a variegated effect, or as in the case of green trees, lightening, darkening, cooling or warming up parts of the foliage, as shown below.

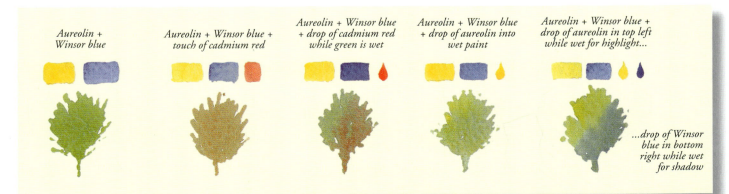

Aureolin + Winsor blue

Aureolin + Winsor blue + touch of cadmium red

Aureolin + Winsor blue + drop of cadmium red while green is wet

Aureolin + Winsor blue + drop of aureolin into wet paint

Aureolin + Winsor blue + drop of aureolin in top left while wet for highlight...

...drop of Winsor blue in bottom right while wet for shadow

The colour wheel

A colour wheel will help you understand how colours react to each other, and one where cadmium red, for example, is used as a primary colour will vary quite markedly from one using alizarin crimson. The version shown here is quite a simple one. Note how each secondary colour, which is created from two primaries, always lies opposite the third primary. These opposite colours are known as complementary colours.

No colour wheel is perfect, but they help us gain an understanding of colour theory. We begin with three primary colours, in this case cadmium red, Winsor blue (red shade) and cadmium yellow pale. Mixing cadmium red with cadmium yellow pale produces a lovely orange, a secondary colour, and from this we can achieve a tertiary colour such as a red-orange by adding more cadmium red to the mixture, and so on. Cadmium yellow pale with Winsor blue creates an interesting green, and if you want to make it look sunnier, simply add more cadmium yellow pale. Winsor blue and cadmium red do not, however, produce the best violet: in fact this version looks quite dull. By using a different primary red – permanent alizarin crimson, for example, a much more exciting violet is produced. Still, the dull colours do have their uses. Try substituting the Winsor blue with French ultramarine or cobalt and see the difference.

Mixing primary colours alone is limiting, which is why we have such a large range of colours on the market. The intensity of many of the manufacturer's colours (for instance, ultramarine violet) simply cannot be achieved by mixing.

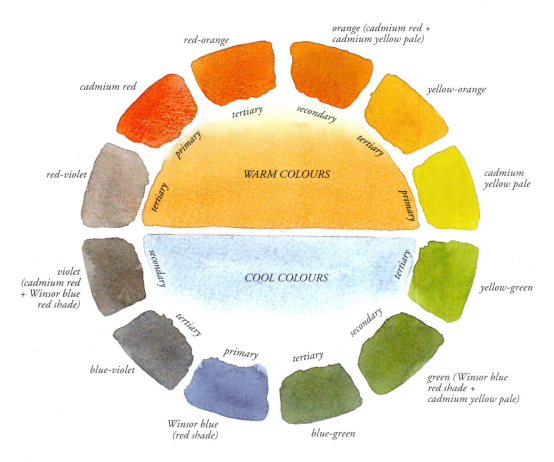

orange (cadmium red +
cadmium yellow pale)

red-orange

cadmium red

tertiary

secondary

primary

tertiary

WARM COLOURS

yellow-orange

cadmium
yellow pale

primary

red-violet

tertiary

cadmium
yellow pale

secondary

COOL COLOURS

tertiary

yellow-green

violet
(cadmium red
+ Winsor blue
red shade)

tertiary

secondary

primary

blue-violet

tertiary

Winsor blue
(red shade)

blue-green

green (Winsor blue
red shade +
cadmium yellow pale)

Complementary colours

The wheel shows us that by juxtaposing complementary colours (those that lie opposite each other on the wheel, such as red and green), we can create striking combinations. Yellow autumn leaves set against a purple mountain backdrop are a good example of this phenomenon. On the other hand, if we mix complementaries, we create a rather dull brownish or greyish colour, but perhaps this is our aim.

Warm and cool colours

The wheel also highlights the warm and cool colours, with warm colours in one half of the spectrum and cool ones in the other. Warm colours draw the eye and come forward, cool ones suggest a sense of space and recede. Each colour range has a variation, with, for example, some reds being cooler than others.

Harmonious colours

If we seek out harmonious colours, then within the colour wheel you can see that those colours in each quarter segment are all in harmony, which is extremely useful to know when you are looking to create a certain mood.

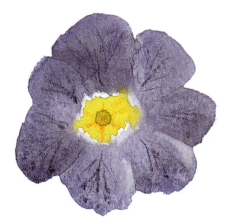

Juxtaposing complementary colours

*Positioning complementary colours against
each other provides a striking effect, as in
this primula with its yellow and violet.*

Painting with a limited palette

As we have seen in painting a monochrome, by restricting our palette we can achieve a
strong sense of unity. Let us now take this further and extend our range slightly.
By using two or three colours and restricting them to within a ninety degree arc
of the colour wheel, we are creating a powerful combination of analogous,
or closely related colours. I sketched the young Zulu warrior (right) using
Naples yellow plus some touches of yellow ochre, then painted his
skin and the background mainly with burnt umber. This method of
working produces a pleasing and unified result without any discord.

The restricted palette of course can come from any part of
the colour spectrum and I chose a more diverse group of
colours for the painting of Lliwedd and Duffryn Mymbyr
Farm below. This scene benefits from the contrast of a
sunlit foreground punctuated by warm yellows and reds set
against the sombre, moody mountain background. Only five
colours were used: French ultramarine, yellow ochre, light red,
burnt umber and some permanent alizarin crimson mixed with
the ultramarine for the foreground shadows. It follows of course that if you use a great
many colours, you will destroy any sense of unity, but many artists prefer such a lively
rendering, and certain subjects can benefit from this latter approach. Bright colours on
a focal point surrounded by a more sombre palette can really accentuate that feature.

Zulu Warrior at Rorke's Drift

*All the colours are in harmony
with each other in this
watercolour sketch.*

**Lliwedd and Duffryn
Mymbyr Farm**

305 x 400mm (12 x 15¾in)

*Here the colours are
deliberately restricted to convey
a sense of mood and unity, with
the warm splashes of yellow
ochre and light red contrasting
the colder colours on the
background mountain.*

Composition

Composition involves the arrangement of the various features within the picture, including the tonal values. Sometimes arranging these elements to the best advantage will be obvious, especially with the less complicated scenes. However, where it does become more challenging, it helps to do a number of thumb-nail sketches to help you decide not only where you will place things, but how large to make them, their relationship with other elements within the painting, where any features need to be subdued or accentuated, and how you will treat the tones. The sketches on pages 61 and 63 show good examples of this process. Here we look at a variety of compositions and how best to tackle them.

The rule of thirds

The green areas indicate the optimum positions for the centre of interest or focal point in a painting.

Warm colour in the sky and building draws the eye and alleviates the coldness of the snow

Focal point: figures and building

The trees form a supporting feature

Approaching Twilight, December

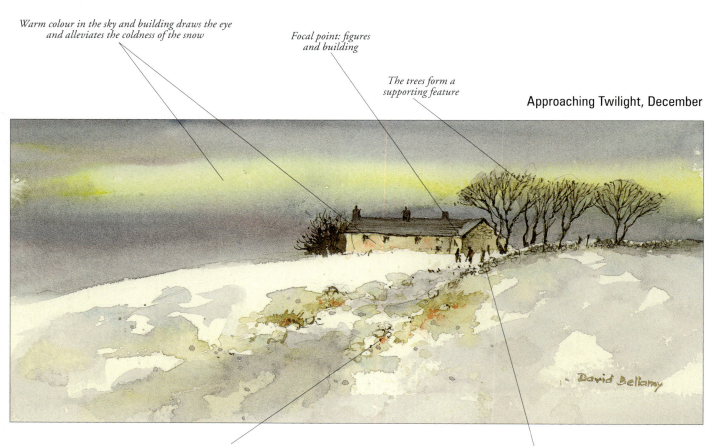

Even just hints and splashes of colour can form a lead-in to the focal point

The focal point lies at the junction of the upper and right-hand thirds

Beach at Sousse, Tunisia

Focal point positioned as in the 'rule of thirds'

The horizon line can look wrong if positioned halfway up a picture, but here it conforms to good composition

Small boat provides balance on the right-hand side of the scene

Strong tones in the foreground help to push the rest of the scene into the distance

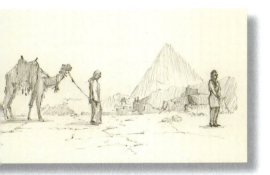

The Tourist, Camel and Bedouin

The bedouin and the camel are walking into the composition, which always works well. The figure on the right is looking out of the picture, is not doing anything and has no relationship with the rest of the composition. She is redundant and the picture would work better if she were cropped out (see right).

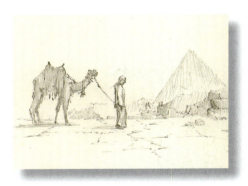

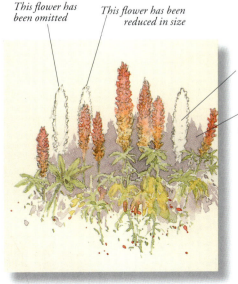

This flower has been omitted

This flower has been reduced in size

This flower has been omitted

Background flowers suggested

Lupins

Left: the scene sketched as seen and showing some of the flowers that would be omitted or reduced in size in a finished painting. The composition could be further improved either by cutting the picture down (as shown on the right), or by bringing one of the outer flowers closer to the centre.

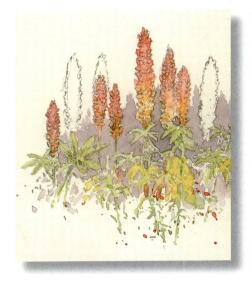

Still life

Many see drawing and painting still life as some kind of chore, to be dispensed with as soon as possible. It is, however, an excellent way of improving your observation and painting skills with easily accessible subject material, as well as being worthy of a full painting in its own right. In so many aspects of painting, having an affinity with your subject can be half the battle, and this is equally true of still life as with any genre. Look to your hobbies and interests – there are bound to be objects in those areas that will excite you. For example I enjoy winter mountaineering and feel a close bond with my ice axe: you will see it rendered with loving care on page 39. I admit that apart from eating the contents, bowls of fruit do little for me, so rule number one is: paint what excites you most.

Most of the still life I do is for material to include in a larger composition: studies of objects outdoors as well as indoors, sometimes triggered by the manner in which light is falling on the feature. I take every opportunity to draw not just people but the objects they use, as in this sketch of the cooks' tent on a Himalayan expedition.

Mingma Cooking

This sketch, done on a trekking expedition, was aimed at acquiring detail for a painting, and involved quite a lot of still life drawing.

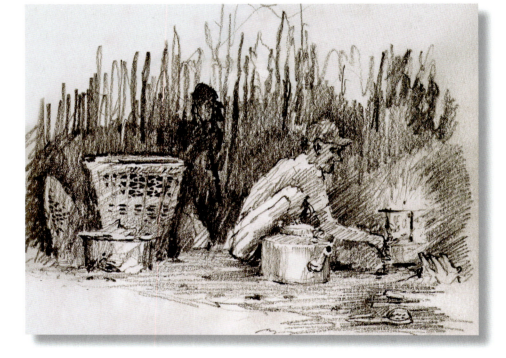

Painting a simple box

1 A flat wash is laid over the whole area except for the light top of the box. This is allowed to dry.

2 A graduated wash is laid over the whole area apart from the top and side of the box, getting darker as it descends to the bottom of the picture.

3 When the previous wash is dry, the dark end of the box is painted with a flat wash.

Firstly though, we will look at how still life can improve our drawing and painting of fairly simple objects. As well as your normal art materials, you will need an anglepoise lamp and a pile of books. Being able to move the light around so that the object is illuminated from a variety of angles, heights and distances will give you the opportunity to create interesting lighting. Sometimes it is worth switching the main light off and even using one or two candles. By placing the object on top of a pile of books, you can then alter the level at which you view the object, thus considerably changing the perspective to suit yourself. We will be covering perspective in the chapter on Buildings (page 82).

Note how, with a simple box, preferably white, the tone of each visible face changes as you move the light about. Even white can appear extremely dark when in shadow. Try drawing a simple box and then painting it with just one colour (see opposite). Paint it by the layering method, in which a new wash is painted over a dried one, each new layer slightly darker than the previous one, as in my rendering. This is a good exercise in laying washes. Move on to more complicated objects – maybe a box of tissues – when you feel confident. Try to avoid highly coloured or patterned objects, as these can confuse.

Brassware in a Cairo Street Market

This is painted from a pencil sketch and a photograph using harmonious colours – yellow ochre, Naples yellow and raw umber on the brassware, with a touch of French ultramarine into the raw umber for the shadows. Once this is done and the washes are dry, the darker background is painted around the tops and sides of the vessels to create outstanding shapes. To achieve this, you might prefer working upside down (the paper, that is) or from the side, as this gives you better control when working round the intricate shapes.

A box of tissues

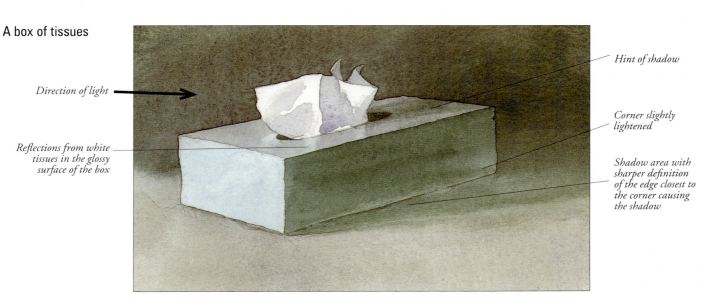

Direction of light

Reflections from white tissues in the glossy surface of the box

Hint of shadow

Corner slightly lightened

Shadow area with sharper definition of the edge closest to the corner causing the shadow

Reflected light and colour

Watch out for reflected light and colours as this will really give your work a sense of authority. We will deal with reflections in water later on. In the illustration below, I perched an orange on top of my white box to create a suitable reflection of an interesting colour. The orange reflection is dropped into the white box top directly after I apply clean water over the surface, and this ensures a soft transition from orange to white. Try this with various objects, using a strong light and colour with a white surface on which to reflect the colour. Develop the sense of observing examples of this wherever you are, even if you cannot sketch the object. I carry an A6 sketchbook in my pocket so that I can use it when in a bar, train or wherever.

Oriental Designs

In this ink drawing I laid watercolour washes to highlight the coloured effects caused by both the cast light and reflected light.

Orange and Box

This illustrates how each object affects the other in terms of reflected light and colour. When setting up something like this, you need to move the objects around relative to each other to find the optimum effect, and even the light itself if you can.

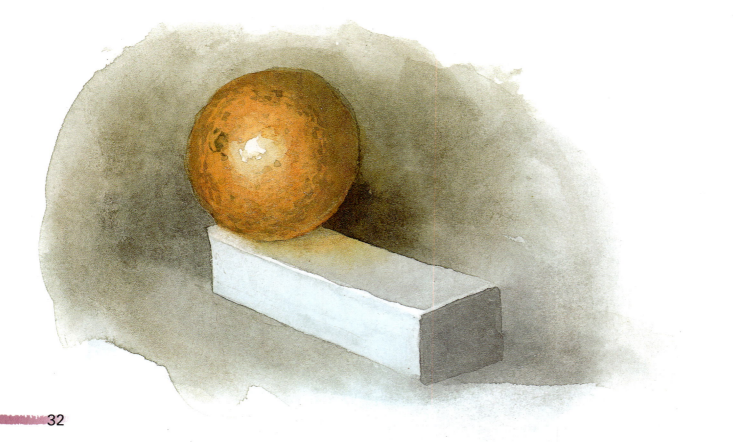

32

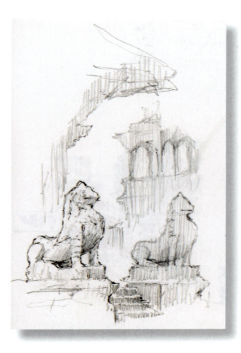

Studies outdoors

Many is the time I have failed to get excited about a panorama I had hoped to sketch, only to find something stuck in a ditch, such as dead, frost-rimed oak leaves. Although I would not include them individually in a landscape painting, they make a fascinating feature as a still life composition. Other objects, such as gateposts, lengths of old weed-flecked marine rope or rusting farm implements I love to draw in detail, as these can be included in a landscape and are extremely useful if you need extra features to improve the composition. If you get excited about piles of cans of baked beans, then take your sketchbook along to the supermarket!

Stone Lions, Durbar Square, Patan

Sketching objects outdoors is invaluable, but think about your main reason for choosing a certain object. Is it to catch the light and shadow? The strong textural effects? Fascination with the object? How do you intend to use the sketch? This thinking will help you concentrate on that aspect of the feature that is most important to you.

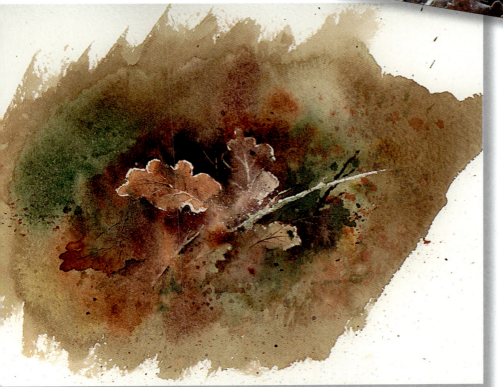

The original subject.

Dead Leaves

After drawing in the outlines with a 3B pencil, a white wax crayon is drawn around the outlines of the leaves, missing out some of the outline to create a lost and found effect. This forms a resist to the watercolour, creating an edge delightfully varied in width and raggedness. A number of colours are washed over the paper: burnt sienna, perylene maroon, yellow ochre, viridian, light red and a few touches of aureolin. These all merge into each other.

Once the paper is dry again, the darker tones are rendered and leaf and twig shapes suggested, sometimes by painting negatively around their shapes with a darker colour and sometimes by describing them with dark tones over the earlier light washes. I leave many edges to disappear. The spattering is done in two stages: firstly while the paper is wet, and secondly after all is dry, including some spatter in the centre with white gouache.

33

Creating textures

Textures in a still life painting are a vital means of suggesting authenticity and can be rendered in some detail, but as part of a landscape they need only be suggested. Here we look at a few examples of various textures which suggest the sort of material that makes up the object. In particular, note how important it is to soften certain edges.

Stalk

Note the change of colour in the stalk, the dry brush work where a darker red-brown is laid over a light red at the top, and some spatter from a toothbrush. These help to suggest texture.

Sewing Basket

140 x 220mm (5½ x 8⅝in)

The basket-work is suggested, with more emphasis in places, and using a varied width of line for the detail. The irregular rings of the basket help to convey the material and its texture.

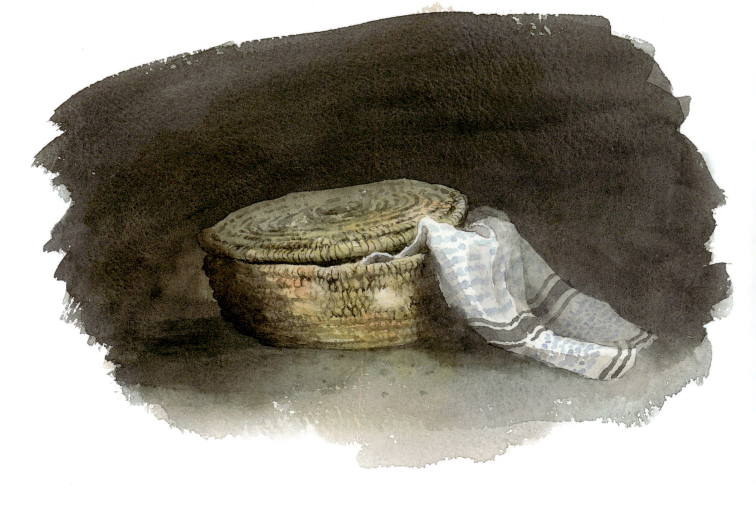

Backgrounds

Setting the object within its context is important, whether it is a still life painting or the object is part of a greater scheme. Sometimes this needs to be changed or the effect heightened, but it is vital not to clutter up the background or surrounding area with too much detail. As a result, many backgrounds need considerable simplification, often to the point of just a plain wash, in order to make the most of the object and avoid confusion. A soft, wet into wet background with indeterminate shapes can often work best.

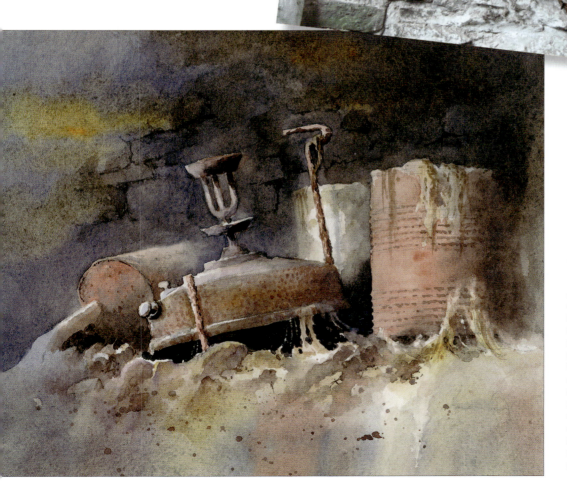

The original subject, giving an idea of the amount of simplification carried out.

Rusty Primus Stove

140 x 170mm (5½ x 6¾in)

I was keen to render the texture of rust on the side of the stove. Firstly I applied a mix of light red with a touch of French ultramarine to the side of the stove, and while this was wet, I dropped in a little cadmium orange in the centre. Once dry, I stippled in the pock-marks using a slightly stronger version of the initial wash. The background is underplayed by making it quite dark and merely suggesting rough stonework.

Realism or a looser approach?

Most people when they begin painting strive for as realistic a painting as possible, and this is an excellent way of learning to render features. It is, however, impossible to record nature exactly as it appears, and we do need to simplify things in order to turn the scene or object into a pleasing work of art. Leaving out various items goes some way to help, but you can also try the following: turn a feature into a silhouette, suggest only part of the detail and leave out the more repetitive bits, or subdue detail with an overlaid wash. Look at the two versions of a corner of Jenny's potting shed to see what I mean.

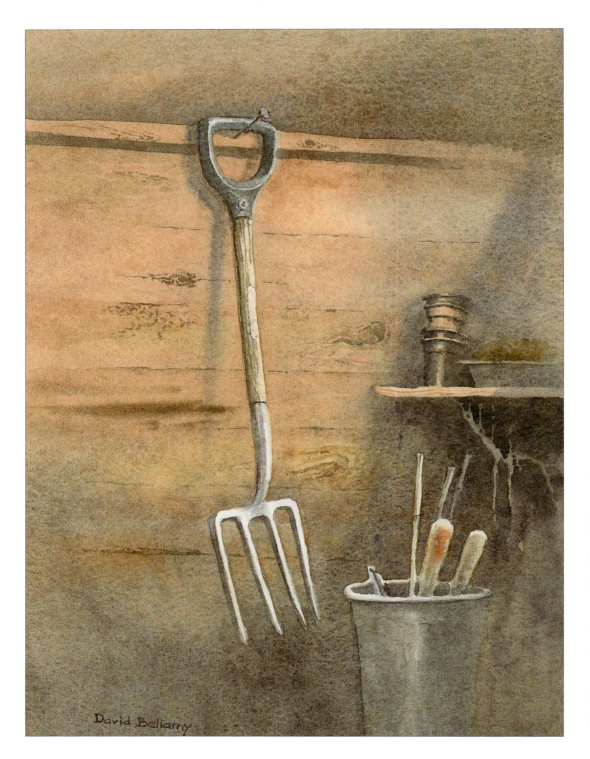

Potting Shed I

270 x 190mm (10⅝ x 7½in)

This is a fairly realistic rendition of garden tools, the fork appearing bent and worn from use. While this is an excellent study in observing and drawing the subject, it lacks a sense of mystery and feeling. In this type of work careful drawing is vital. The fork and many of the objects are defined by painting dark washes around the objects, i.e. negative painting. The soft shadows are achieved by laying the colour on to a surface that is already wet with clean water.

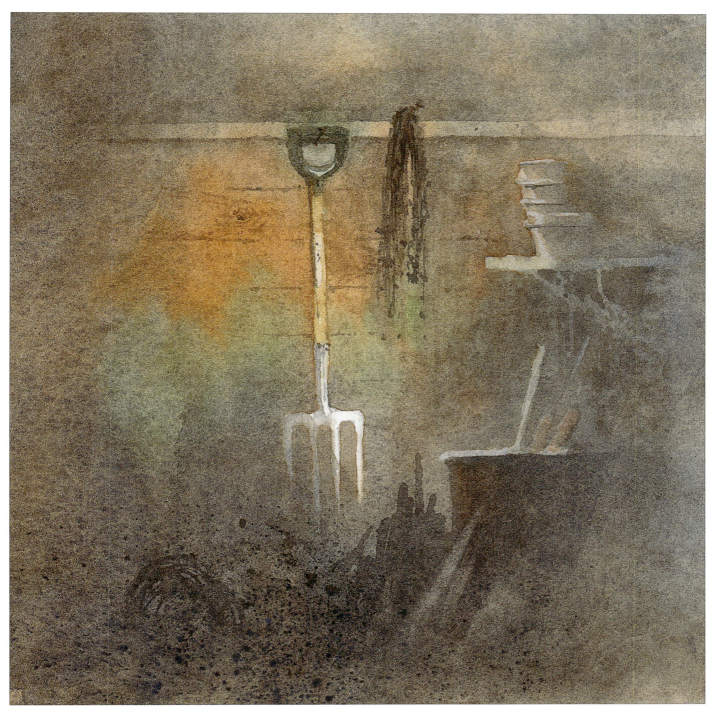

Potting Shed II

160 x 140mm (6¼ x 5½in)

In this version a sense of mood invades the scene. By employing dark glazes across some of the details, leaving only part of the fork highlighted, I have created an air of mystery. Silhouettes and half-seen objects, created by rubbing a damp 13mm (½in) flat brush across to lift out colour, further add to this feeling. The wooden wall, pots and shelf are underplayed. I prefer this version, even though this potting shed looks like a fitting place for a murder!

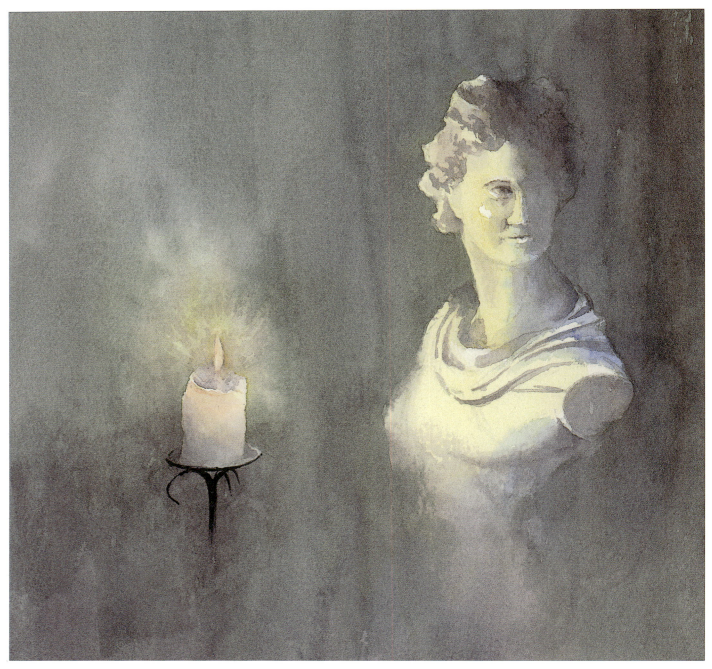

Bust by Candlelight

220 x 180mm (8¾ x 7¹⁄₈in)

Using the soft light of a candle to illuminate your still life will help you to achieve a sense of mood similar to Potting Shed II on page 37. Experiment with the object at various distances away from the candle, or maybe have two candles, each at different distances. This is almost a monochrome apart from the Naples yellow glow and a touch of permanent alizarin crimson in places, an effective technique in low light. Note how important the softened edges are in fading out the image as it goes away from the light.

Still life as a decoration

When on expedition or travelling I always keep an illustrated journal, and while the main focus of my work is on landscape, I also include people, wildlife and various objects of interest. These objects are sometimes in my sketchbooks, sometimes in my journals, and I like to use them on title pages or certain points in the books where they add to the effect and combine with writing. This can involve a still life object such as an ice axe, dog-sledge, Zulu shield or even something as mundane as an old rusting oil drum – anything that has made a significant impression. Watch out for these often humble objects, as they can greatly enhance your sketchbooks and journals.

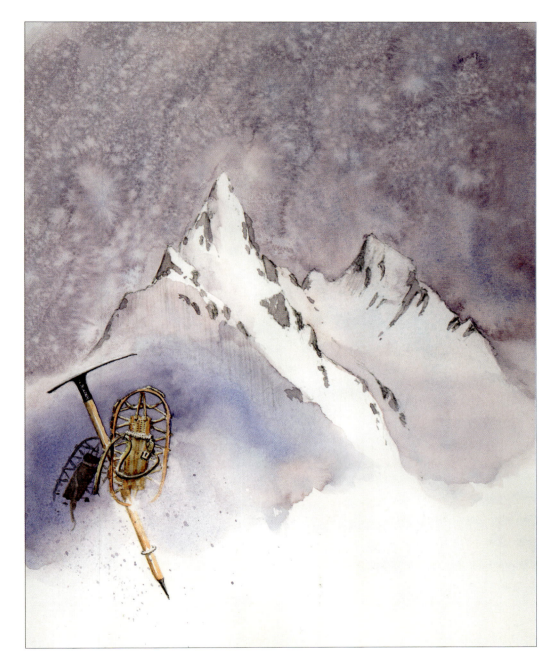

Ice axe and snow shoes

This watercolour study on cartridge paper means a lot to me. Our cleaner hates seeing my ice axe lying around and wraps it up in copious bundles of rags, whereas I treasure it, as it has saved my life countless times. My point here is that if you have a tremendous affinity with an object, you will do a much better job of depicting it than usual, even if, like me, still life is not your prime motivator. The mountain was sketched on location and the axe and snow shoes put in later, indoors.

Pottery Still Life

When you are setting up a still life composition, you can juggle objects around to suit yourself, trying different combinations and positions until you are happy that you can go ahead with the drawing. If you can also move the light around – or more than one, perhaps – then so much the better. Try to find objects that appeal to you, as you will then be more likely to respond better. Remember, this is not just an exercise in painting a picture of an object or group of objects, but a means of learning how to develop a painting in watercolour, managing tones, getting the best out of your colours and so much more.

The still life, set up for painting.

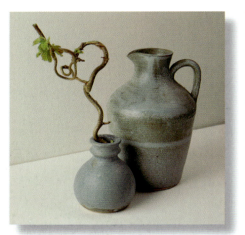

1 Draw the scene through careful observation. Note that I have slightly changed the stem, adding a gap between the twists.

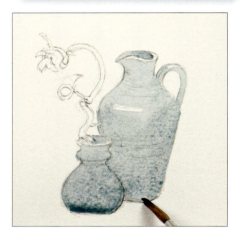

2 Make a thin mix of cobalt blue and raw sienna and use the no. 7 brush to wash it over the jug and the pot, leaving white highlights on the rims and handle.

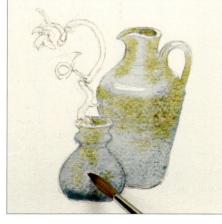

3 Drop in raw umber, while wet.

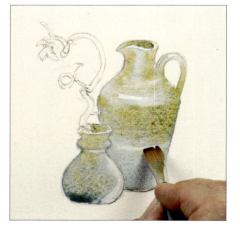

4 Use a damp 13m (½in) flat brush to lift out colour, suggesting reflected light. Allow to dry.

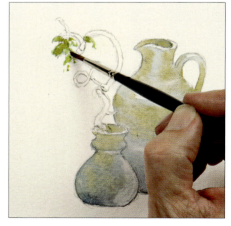

5 Change to the no. 4 brush and use a mix of cobalt blue and new gamboge to touch in the leaves. Add a hint of unmixed new gamboge to vary the colour.

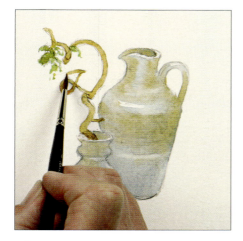

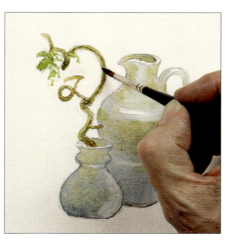

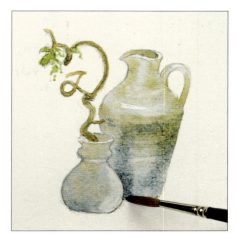

6 Use a wash of raw umber to paint the twisted stem.

7 Working quickly while the wash is wet, mix ultramarine with raw umber and drop this into the first wash on the stem.

8 Re-wet the jug with the no. 7 brush and clean water. Paint in soft-edged shadow to the lower part using the ultramarine and raw umber mix. Lift out some of the colour with a damp brush.

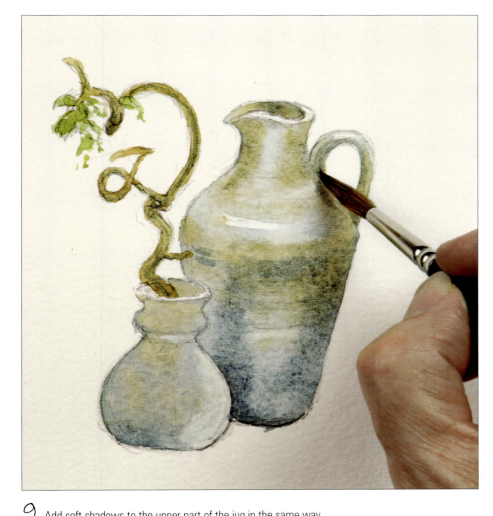

9 Add soft shadows to the upper part of the jug in the same way.

10 Re-wet the small pot and drop in soft shadows in the same way. Note that the lighter part of the neck is underneath, because light is reflected up from the white surface. Add a dark area between the direct light and the reflected light on the right-hand side, to make the pot appear rounded.

11 Paint the dark details on the pot with the no. 4 brush and a mix of burnt umber and ultramarine. Soften the top part as it curves over the lip to the lighter area.

12 Sharpen up the plant stem with the same mix. Curve the brush around to suggest the roundness of the stem.

13 Re-wet the right-hand side of the jug's spout and drop in a shadow using ultramarine and raw umber.

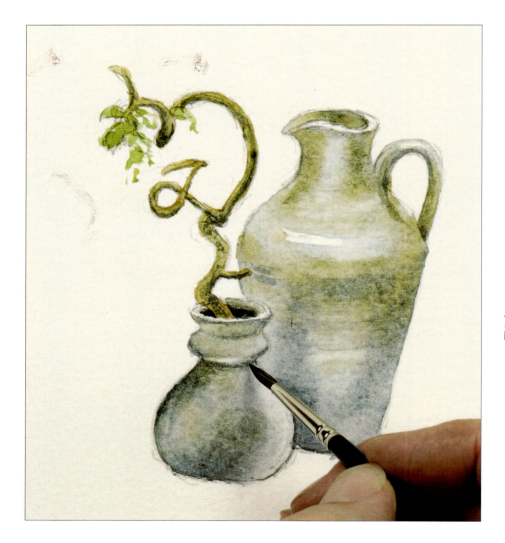

14 Use the same shadow mix to darken beneath the neck of the pot.

15 Mask off the edges of the jug with scrap paper or paper tissue. Dip an old toothbrush in a mix of cobalt blue and raw sienna and spatter the lower part of the jug. Remove any unwanted drops with a damp paintbrush.

16 Change to the 00 brush and pick up a little Naples yellow mixed with white gouache. Touch in little blobs on the plant stem for texture. You could also use a no. 0 or no. 1 rigger for this.

17 Repair any unwanted marks. I had made a blot at the bottom of the jug. Take the 13mm (½in) flat brush, dampen it and lift out any unwanted colour. Use an eraser to rub off any obtrusive pencil lines.

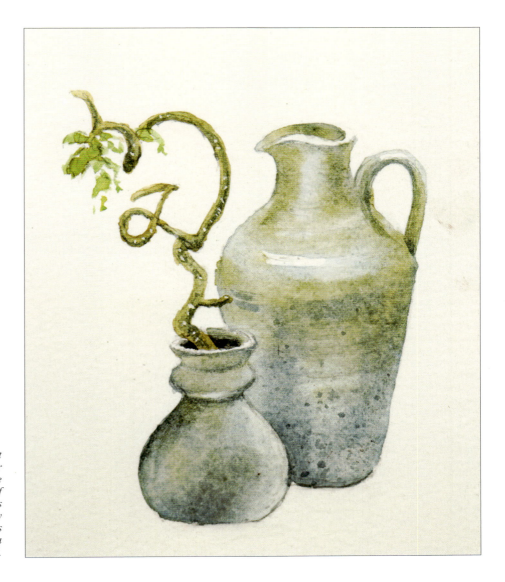

The finished painting. What I like most about this painting is the blobby spatter that represents the lovely texture on the jug – yet this was the least controlled of all the brushwork in the painting. This is the charm of watercolour; the spontaneity you get when letting the medium have its way and allowing yourself to get just a little out of control.

Flowers and plants

Flowers and plants are among nature's most accessible beauties, whether in the house, garden or landscape, so there is ample opportunity to work on a variety of subjects in this field. Indeed, these can be in such profusion in summer that the main problem is often in restraining one's eagerness to paint every tempting bloom and leaf. While they make splendid compositions on their own, they can also provide superb foregrounds in a landscape painting.

Clarity and intensity of colour

You may be able to get away with a slightly muddied wash here and there in a landscape painting, but in the case of flowers you really do need to achieve colours that are clean, intense and vibrant. In watercolour it is essential to keep brushes and palettes clean, colours fresh and unsullied, and paper flawless, not rubbed to death by multiple abuse with an eraser. When you are painting flowers, this is of vital importance, but it is a good standard to maintain whatever your subject. To get the best out of colours, paint only on to pristine white paper, so reserve your whites carefully for this. Work out your composition on scrap paper first, and do any rubbing out there, before transferring the image to watercolour paper. Try to achieve as close a likeness as you can to the actual flower colour.

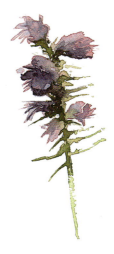

Viper's Bugloss

Achieving the intensity of colour that we see in a bloom is vital and for this it is best to use the closest colour possible straight out of the tube, as mixing two colours to create the same is rarely effective. In these mixing examples the ultramarine violet with touches of permanent alizarin crimson produces the most vibrant result.

cerulean blue + permanent alizarin crimson

Winsor blue (red shade) + permanent alizarin crimson

ultramarine violet + permanent alizarin crimson

Cow Parsley: the importance of painting on a white surface

To retain the white surface for these wild flowers, masking fluid is painted where the yellow petals and the cow parsley heads and stalks are to appear. Then the green background is laid on, dropping in yellows to create variety, then suggesting some darker detail once the green dries. When the masking fluid is peeled off, the stalks are washed over with a weak mixture of cobalt blue and yellow ochre to reduce the starkness. Weak raw umber is painted on parts of the heads and aureolin on the celandines. Simply dabbing the yellow over the dark greens will not work in watercolour because it is almost impossible to paint a light colour over a dark. Compare this with the technique using white gouache on page 53.

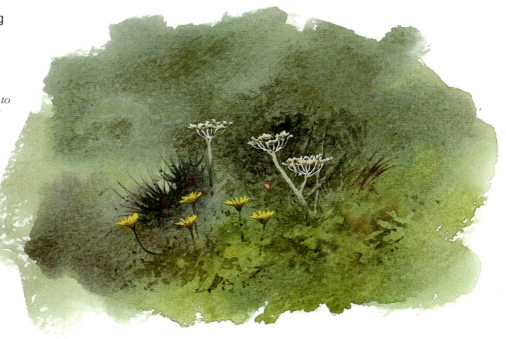

Working with wet paint

In order to create soft edges and shapes we use the wet-into-wet technique. While this is an extremely effective way of working, it does call for good timing and control. If you paint into a wet wash too soon it will fade out weakly into the wash, and if you apply it too late it will form ugly cauliflower-like runbacks. The brush needs to be damp, not wet, and this can be assessed by testing on scrap paper. With experience you will note that as the sheen is going off the wash, that is the optimum time to apply the second colour. Usually there is somewhere you can dab in a mark to test if the wash is ready to accept the second application, perhaps on the side where it is not going to be a problem, or in the middle of a large area that you intend to paint. Sometimes the shapes thus formed are not critical, as with the variegated leaves illustrations. The soft-edged shadow on the pot of nasturtiums, however, does need a more controlled and definite shape. Experiment with your own versions of the illustrations on this page, trying several of each, perhaps using different colours.

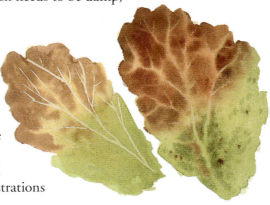

Using masking fluid for veins *Lifting out veins with a brush*

Variegated Leaves

The left-hand leaf is done using masking fluid to suggest the veins, while the right-hand version is painted with an initial wash of Naples yellow. This is allowed to dry, re-wet, then with a mixture of perylene maroon and burnt umber the top half is applied, leaving the lines of the veins unpainted. The mix has very little water, otherwise it would rapidly run into the wet area and cause runbacks. The paint will inevitably seep over the lines in places and in most cases can be recovered by using a flat brush end-on to create the many small branches. When this dries, the lower half is re-wet with a generous overlap on to the red area, and the above procedure is repeated using green. The reason for re-wetting rather than working straight into the Naples yellow wash is to avoid losing the Naples yellow when the flat brush is used.

Working into wet paint

Although this is a small watercolour, the processes involved are quite tricky as there are colour changes in the pot, soft and hard-edged shadows, highlights, reflected light and texture. If we break this down into stages we can make it easier for ourselves:

1 A permanent alizarin crimson and yellow ochre mixture is brushed over the pot, leaving white untouched paper for the highlights, and while this is still wet, a green mix of new gamboge and cobalt blue is touched in at the bottom of the pot to blend in softly.

2 Once the pot is dry, the right-hand side is re-wetted to just below the handle, leaving the top left-hand side dry. A mixture of French ultramarine and cadmium red is then washed across the shadow side and up into the top dry area to define the handle and its shadow. Where the wash is laid on the wet area it creates a soft edge. With an old damp sable, I lift out colour from the shadow side to suggest reflected light, and spray water gently over it to create texture while the paint is starting to dry.

3 The flowers are painted in, dropping other colours into some to suggest a change in the colour of the leaves, and finally the dark shadows define some of the leaves and the sides of the pot.

Emphasising certain flowers

Here we look at how we can highlight particular flowers in the garden, where there is a variety of flowers and plants competing for attention. Painting a riot of colour can be exciting, but covering the whole of the composition with unending colour masses can be a little overpowering. By suggesting depth and subduing the more distant parts of the scene, we can throw emphasis and interest on to the main features. In the step-by-step example below, all colour has been muted except for that on the main blooms, although there is nothing wrong with including more colour.

1 While the petals are rendered with permanent rose (as well as the foxgloves in the rear), several patches of white paper are left on the blooms to enliven the flowers. Some cadmium yellow deep is placed in the centres. Once the pink is dry, a wash of French ultramarine is laid across the paper, working round the flowers but covering most of the foxgloves in order to keep them subdued. Once this is dry, the dark green leaves and stems are painted.

2 A dark mixture of French ultramarine and cadmium red is laid across the lower half of the painting, working round the stems and suggesting more plants in the rear.

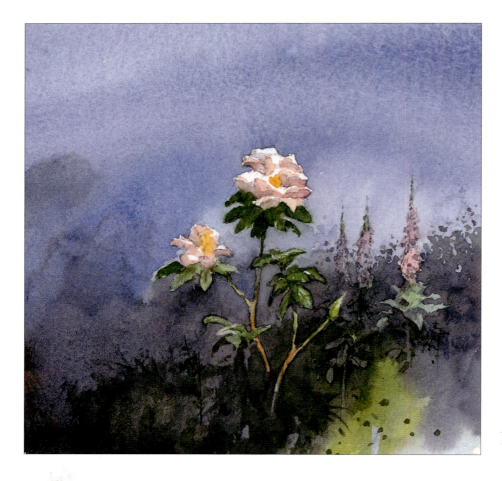

Pink Roses
150 x 150mm (6 x 6in)
At the final stage, more foreground detail is described.

46

Losing unimportant detail

If we take a vase of flowers, even here we are confronted by much detail, a great deal of which needs to be either left out or subdued in some way. Begin by arranging the flowers to suit yourself, and adjust the lighting if necessary. Which is the most pleasing bloom, the one that immediately catches your eye? Position the other flowers to support the ones you have chosen as your focal point until you feel your composition works. You may need to rearrange these more than once. Now it is time for the pencil. How big do I make the blooms? What do I subdue? If the answers to these questions do not immediately strike you, it is a good idea to rough out a thumbnail sketch on cartridge paper using a soft pencil. Draw the flowers you have chosen as your focal point first. Add in supporting flowers, including leaves and stems, but do not make these so prominent. Then suggest some background detail and further features on either side of the centre of interest. Finally put in the vase, or perhaps just part of it. Maybe you need then to accentuate the main blooms with stronger pencil strokes, and even subdue the other elements, perhaps by light shading over them. Do not feel you have to include every flower. If it is still not quite right, add or subtract details, or move them slightly. If it gets too messy, start on a new sketch. Gradually your picture will emerge.

Before you draw the image on watercolour paper, consider the size. This is often best worked out by looking at the most important blooms and deciding how big you would like them to be, then the rest of the composition will follow. Transfer a light outline of your sketch on to the watercolour paper, then work in the details from the actual flowers. In the painting, you can suggest the background and outer features by the wet-into-wet method or simply a weak silhouette with all the various suggested elements running into one another and little or no detail showing. You can subdue features either by gently washing over a soft sponge with clean water, or by laying a light glaze of colour across that part of the composition.

A Vase of Flowers
240 x 180mm (9½ x 7in)

Painting each bloom in strong detail can create monotony, whereas playing down some of the flowers and emphasising others leads to a more exciting composition. Here I use soft edges, lost detail and shadowy, suggested shapes to create an air of mystery. Too many hard edges will overstate the features. To create the hard edges here I use masking fluid, but even so I subdue many of these with a medium-toned wash such as that over the lower white gerbera.

Isolating blooms

Creating a background to garden flowers while at the same time isolating them can be fraught with numerous pitfalls for the unwary. One approach is to paint the background in a monochrome that contrasts strongly the main blooms, yet having part of the scene merging from the foreground colour into that monochrome area. This procedure can be seen clearly in the Poppies watercolour where the star shapes run back into the darker monochrome. Within that monochrome area are strong, yet subdued shapes of plants that put the poppies in their garden setting without overwhelming the two main flowers. Try this method of working with flowers of your choice. It is an excellent technique for simplifying a scene and also works well if for example, you wish to make a greetings card or decoration in a journal page.

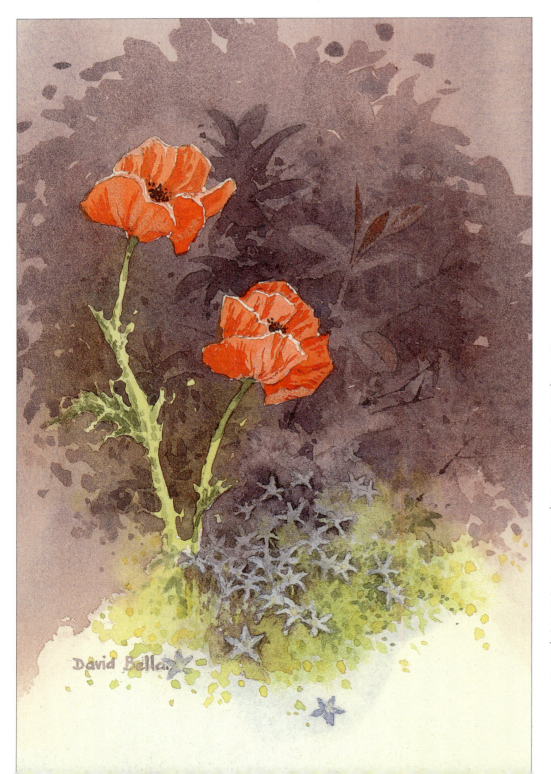

David Bella

Using a monochrome background: Poppies

210 x 135mm (8¼ x 5¼in)

To throw more emphasis on the poppies, I cover the background with a monochrome wash. I begin by laying masking fluid over poppies, stems and stars, then lay a weak wash of French ultramarine and perylene maroon over the background. When this is dry, I use a stronger mixture of the same colours to splash in the darker silhouette and again let this dry before painting in the dark background shapes using just about the strongest mixture these colours will allow. As I do this, I let some of the edges disappear and work round leaf shapes to suggest lighter leaves. The masking fluid is rubbed off once the paper is dry and the poppies rendered with scarlet lake. The green is a mixture of cobalt blue and cadmium yellow pale and the star-shaped flowers a weak cobalt blue with ultramarine violet in places. These shapes work well in a vignetted foreground.

Sunlight effects in the garden

Creating a natural feeling of warm sunshine in your garden paintings can give your work a real lift. For this warmer effect, choose your colours carefully: warm reds and yellows for those flowers in sunshine, and cool versions for those in shadow. Do the same with greens for plants and foliage. By placing a cool blue-green against a warm orangey-yellow you will make the latter appear warmer.

The one feature that really suggests sunshine more than anything else, is of course, the cast shadow. If you lay down the colour of the feature over which the cast shadow will fall – a path perhaps – and let it dry completely, you can lay a transparent glaze over the area to suggest the cast shadow. A warm blue, such as French ultramarine is excellent for this, often with a hint of red such as permanent alizarin crimson, or a cadmium red if you need the shadow a little stronger. Observe the edges carefully: are they hard or soft? Laying cast shadows across a patch of flowers is just the same, only the edge needs to be less definite and more ragged.

1 Although I could have used masking fluid I prefer to paint negatively, bringing out the lighter shapes by painting the darker forms around them. In this stage the light colours of the flowers and vegetation are painted, as well as the light-coloured foreground. Quinacridone magenta is applied to the left foreground flowers, and ultramarine violet to the right-hand ones.

2 More of the vegetation is rendered, the background with viridian modified in places with raw sienna and raw umber. Note the strong foreground detail definition.

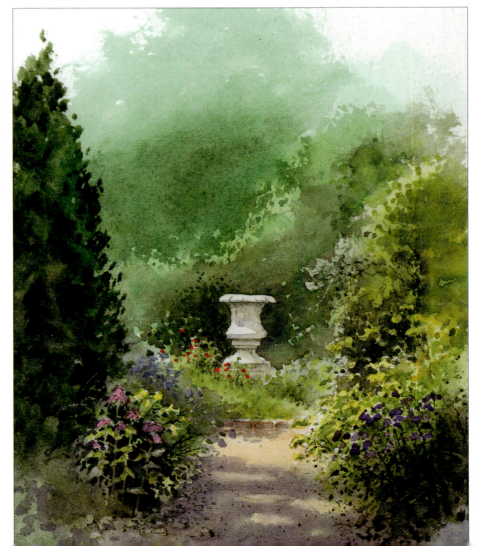

A Quiet Corner of the Garden
160 x 130mm (6¼ x 5⅛in)

The finished painting. My aim was to create a sense of sunlight and shadow, but this is also a lesson in tackling summer greens. Note the cool, bluish greens in the distance, and how they contrast and emphasise the warm, sunlit ones. The dark, warm green on the left-hand conifer and foreground shadowy parts is achieved with a base green of viridian, mixed with raw umber. In the really dark places I touch in some French ultramarine and burnt umber. The soft shadows over the path are created by washing a mix of French ultramarine and cadmium red over damp paper, leaving the sunlit gaps. As it dries I use a damp flat brush to lift out any of the colour that threatens to close these gaps.

A trailing plant

Trailing plants do not just make attractive subjects, but can also act as an excellent lead-in to a composition, or can drip down off an old bridge or over a doorway. As a lead-in they are effective when introduced as a vignette, where the rest of the detail in a scene stops while the trailing plant curves down to the bottom. Entangled around other features or plants, they can suggest a wilder, less formal area of garden, or in the wild can be part of more riotous undergrowth. I sometimes like to combine them with brush spatter, which tends to give a sense of spontaneity. While some of the leaves are still wet, I like to drop in other colours, such as red and orange, particularly with late summer or early autumn scenes.

Trailing Plants
160 x 140mm (6¼ x 5½in)

A variety of plants festooned this little-used packhorse bridge, almost obliterating the stonework. Trailing greenery works well to break up the hard edges of rocks and stonework. As usual I work from light to dark, painting the darkest with French ultramarine and burnt umber. When all is dry, a scalpel is used to scratch out a few tendrils here and there. Note how on the right-hand side the dripping plants on the far side of the bridge are painted with weak French ultramarine and cadmium red with exactly the same mixture and tonal strength as the boulders defining the far bank.

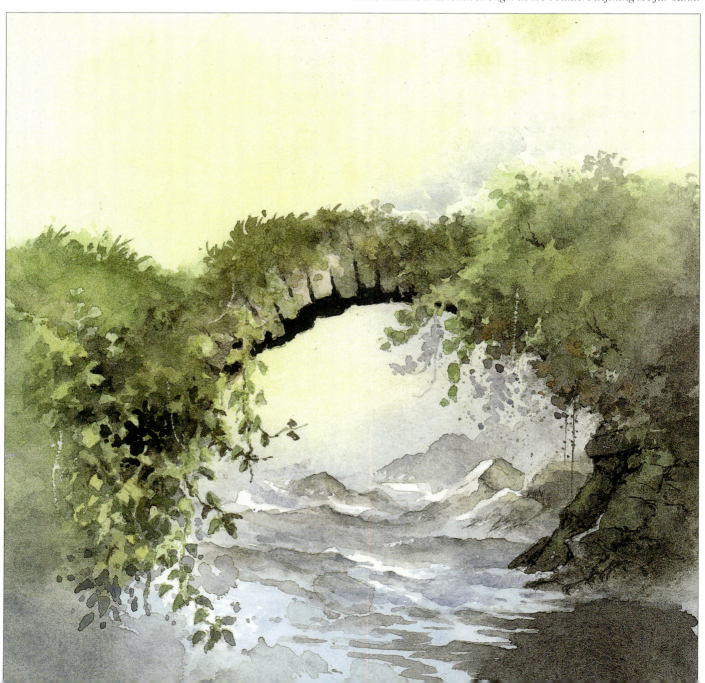

Painting a mass of undergrowth

There are times when we need to include hedgerows or massed undergrowth in a scene, and with such a chaotic mass of intertwined plants, weeds and flowers it can be daunting. You need to limit the amount of intricate detail, suggest it in places and use colour as a substitute for detail when you can. Spattering paint across flat or variegated colour passages can work well. Pick out the best bits of the undergrowth: the most handsome plants or flowers, and emphasise these. Briars and stalks are useful for linking parts and introducing variety of shape. Note how briars, stalks, stems and branches often change colour and tone over their length, and this can be an attractive way of adding interest to a humble plant, even when this colour change is not present.

An alternative way of coping with undergrowth is to paint in the strongest specimens and then make an abstract or semi-abstract of the rest of the undergrowth. Base this on natural forms, unless you wish to suggest some artificial object lying among the mass of vegetation, such as an old farm implement or rusty oil drum perhaps. This object could also be abstracted. See page 71 in the Landscape chapter for an example of an abstracted foreground. Undergrowth, whether in the form of hedgerows or uninhibited wildness seems difficult at first, but with some strong focal point, a few well-chosen plants and the main mass simply suggested, you will find that gradually you can evolve a system for coping with this natural chaos.

Massed Undergrowth
150 x 150mm (6 x 6in)

For this abandoned old gate overgrown with vegetation I paint masking fluid over the gatepost, some of the plant shapes and the gate. In a subject like this, one of the main dangers is that it is tempting to paint every leaf. By defining a few and suggesting the rest with variations of colour I have tried to make it look less fussy. Once all the paint is dry, I draw in a few brambles with a rigger and suggest the texture and grain in the wood, using burnt sienna with a touch of French ultramarine in places. Finally I spatter some of this mixture across the foreground.

Painting undergrowth with the negative technique

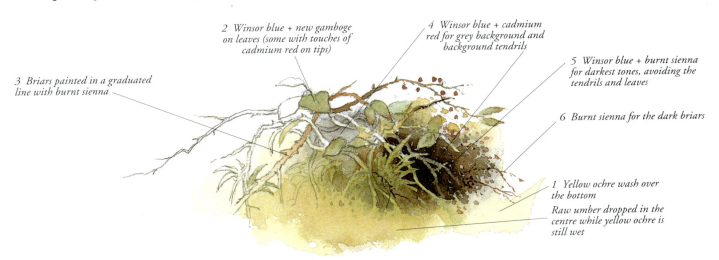

2 *Winsor blue + new gamboge on leaves (some with touches of cadmium red on tips)*

4 *Winsor blue + cadmium red for grey background and background tendrils*

3 *Briars painted in a graduated line with burnt sienna*

5 *Winsor blue + burnt sienna for the darkest tones, avoiding the tendrils and leaves*

6 *Burnt sienna for the dark briars*

1 *Yellow ochre wash over the bottom*

Raw umber dropped in the centre while yellow ochre is still wet

Defining flower shapes with negative painting

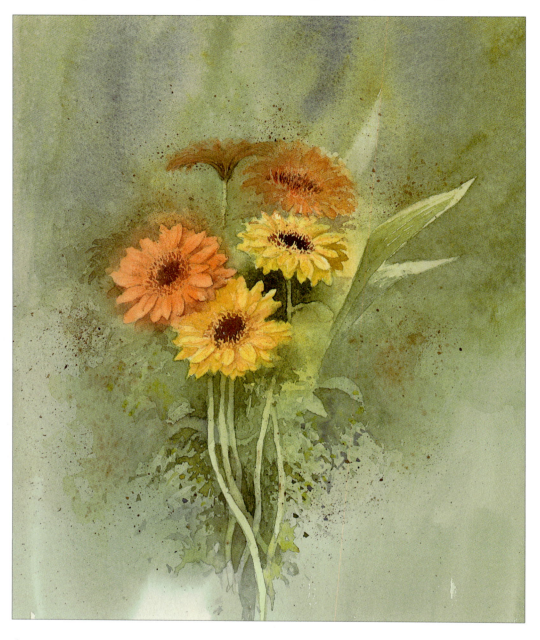

Gerberas

260 x 210mm (10¼ x 8¼in)

Most of the shapes here are defined by negative painting. I love the way the stems intertwine, and decide to make a feature of this. The background green is a mixture of Winsor blue and quinacridone gold which I spatter with water before it dries, to create texture. For the red flowers, cadmium red and cadmium orange is painted on, and where the petals appear lighter these highlights are created by lifting out colour with a small, damp brush. The yellow ones are achieved with new gamboge and quinacridone gold, with touches of raw sienna in places.

After the basic shapes of the stalks are defined, two or three layers of slightly darker greens are washed over parts of them to suggest shadow – this is readily apparent directly under the yellow blooms. The strongest darks, to outline the stalks, are then painted in, with especially strong tones under the top yellow bloom to draw the eye in to the focal point. For the warm darks of the centres of the flowers I use a mixture of quinacridaone red and Winsor blue.

Flowers in the landscape

Flowers can make an excellent foreground to a landscape painting in order to add detail to an otherwise bland scene, to cheer it up with some colour, or as I often do, to suggest a gentle, civilised oasis of beauty amidst a scene of unadulterated mountain savagery and gloom, perhaps with an approaching storm for further effect. They also add considerably to a composition when placed beside a focal point in the middle distance, drawing attention to this feature through use of bold colour and perhaps variation. Red flowers against a white building work exceptionally well, particularly if accompanied by a splash of warm green.

Ox-eye Daisies

210 x 260mm (8¼ x 10¼in)

A really effective method of painting wild flowers is to create a dark area and once it has dried, paint on thick blobs of white gouache over the dark parts. Here I suggest ox-eye daisies in the foreground with smaller blobs of paint beyond. Once the white gouache is dry I apply cadmium yellow deep to the centres of the daisies and also to some of the small blobs to suggest buttercups. Note how the flowers really stand out where they are painted over the dark area, but less so elsewhere.

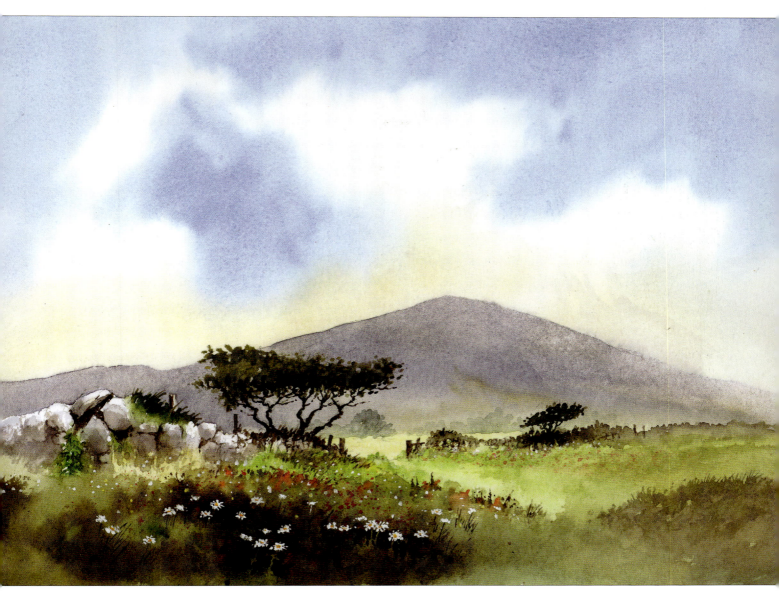

Hedgerow

Hedgerows are notoriously difficult subjects to paint, whether as part of a landscape or as a composition in themselves. You need to establish a strong, definite feature as a focal point, give it slightly less definite supporting detail and suggest the rest with occasional patches of detail or variation in colour. In this demonstration, we tackle a small part of a hedgerow in spring, with particular emphasis on the negative painting technique.

YOU WILL NEED

425gsm (200lb) Not paper
Colours: cerulean blue, French ultramarine, cadmium red, yellow ochre, new gamboge, cobalt blue, cadmium yellow pale, raw umber, burnt umber, burnt sienna, light red, white gouache, Naples yellow
Brushes: no. 7 round, no. 4 round, no. 1 rigger
Paper tissue and old toothbrush

1 Draw the scene. Use the no. 7 brush and a pale sky wash of cerulean blue. Scrub with the side of the brush and leave some areas white.

2 Paint a wash of ultramarine and cadmium red lower down in the sky, wet into wet, then drop in yellow ochre.

3 Paint yellow ochre over the trunks of the saplings.

4 Mix new gamboge with ultramarine and drop this green into the bottom of the saplings. Allow to dry.

5 Mix a duller green from yellow ochre and cobalt blue and paint this on to the left-hand side of the background and behind the saplings.

6 Paint a wash for the hedgerow from the cool green mixed with cadmium yellow pale. Drop in more cadmium yellow pale, wet into wet. Allow to dry.

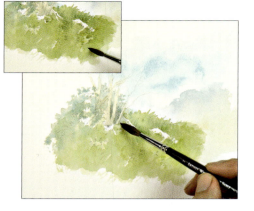

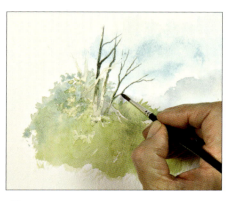

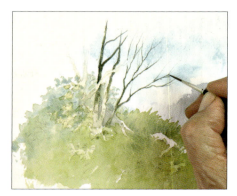

7 Use the warmer green mix of new gamboge and ultramarine to paint the area around the fallen branch. Subdue the area behind the saplings with a weak mix of ultramarine and burnt umber.

8 Change to the no. 4 brush and liven up the foliage by dropping new gamboge into the wet colour. Darken the saplings with a mix of raw umber with a touch of ultramarine.

9 Change to the rigger brush to paint the finest branches and twigs.

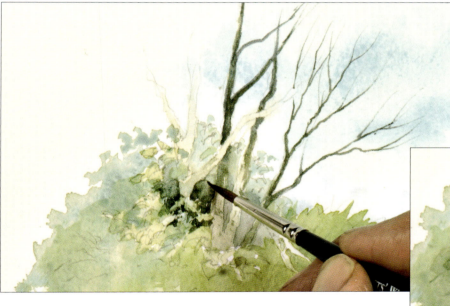

10 Use the no. 4 brush and ultramarine with raw umber to do negative painting around the leaf shapes. At the edges, paint foliage with positive shapes. Soften and blend in with a damp brush. Change to a rigger and paint briars with burnt sienna.

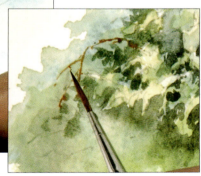

11 With the no. 4 brush, darken the area to the right of the saplings with ultramarine and raw umber. Add burnt umber and ultramarine in the midst of the undergrowth to define the trunks, then drop in light red blobs while still wet.

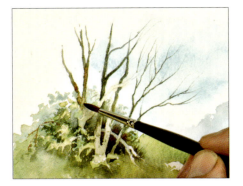

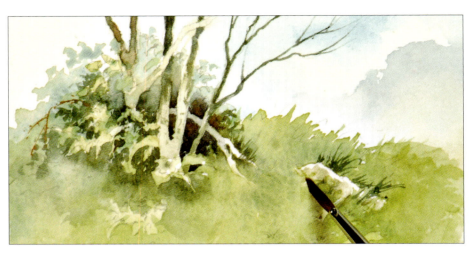

12 Paint the branches to the left with the no. 4 brush and raw umber and French ultramarine. Drop in light red to vary the colour.

13 Mix a dark green from new gamboge, ultramarine and a touch of burnt umber, and use it next to the fallen branch on the right. Paint raw umber on to the lower part of the fallen branch, but leave the top part white where it catches the light.

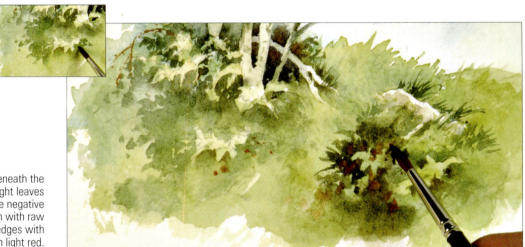

14 Paint more dark green beneath the saplings, suggesting the shapes of light leaves with negative painting. Continue negative painting beneath the fallen branch with raw umber and ultramarine. Soften the edges with clean water. Drop in light red.

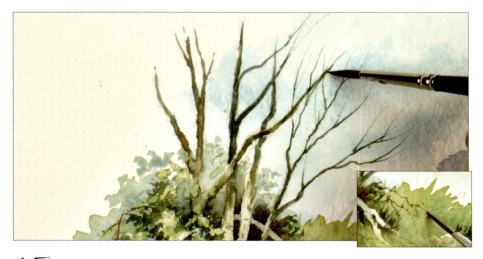

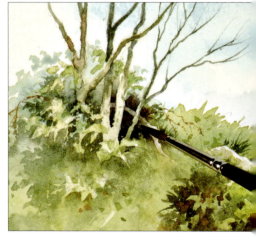

15 Paint the branch of one of the saplings with raw umber and a touch of ultramarine. Blend in and lift out colour so that the branch is lighter against the dark background and darker against the light sky. Use a rigger and burnt umber to paint a few briars coming from the undergrowth.

16 Use the no. 4 brush to shade the cross branch behind the main saplings with a mix of ultramarine and light red. Shade the bottom of the main trunks in the same way.

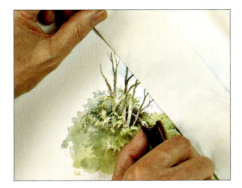

17 Mask part of the painting as shown with a paper tissue. Dip an old toothbrush into a mix of light red with a touch of ultramarine and spatter paint over the hedgerow.

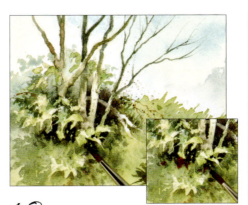

18 Make a strong, dark mix of ultramarine and burnt umber and use the no. 4 brush to do negative painting around the bottom of the trunks, to give the saplings a solid base. Drop in light red blobs while still wet.

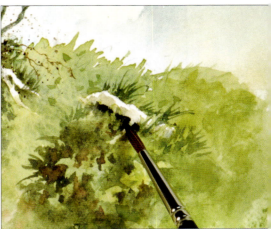

19 Paint under the fallen branch with ultramarine and burnt umber.

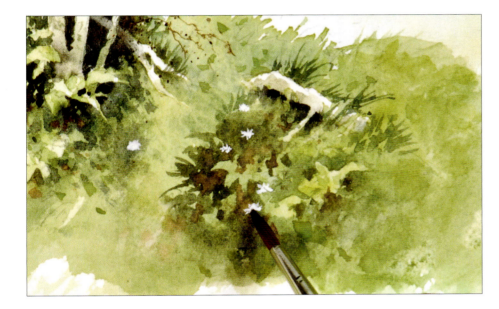

20 Use the no. 4 brush with white gouache to create a light base for the celandines.

21 Paint over the dried gouache with new gamboge on the rigger brush.

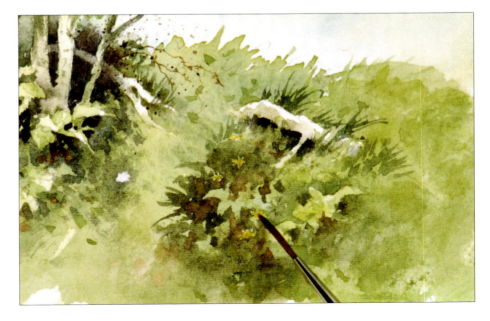

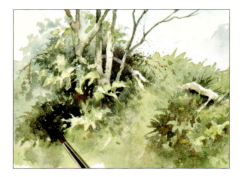

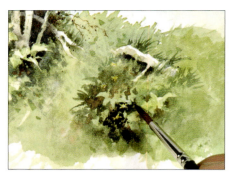

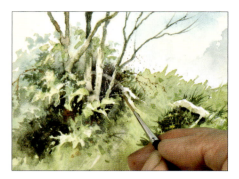

22 With a no. 4 brush, lay in a dark mixture of raw umber and ultramarine below the saplings and leave to dry, ready to paint in some primroses.

23 Use the same colour to paint around some of the celandines that need further emphasising.

24 Mix white gouache with Naples yellow and use the rigger to paint light-coloured bits of twig crossing darker areas of the painting.

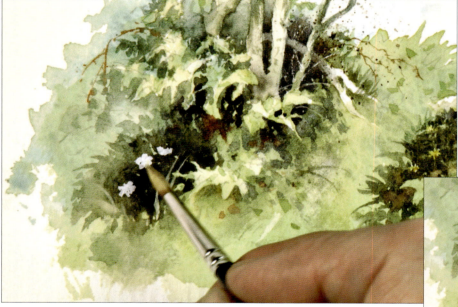

25 Change to the no. 4 brush and paint primroses on the dark area in front of the saplings with white gouache. When this is dry, go over it with Naples yellow.

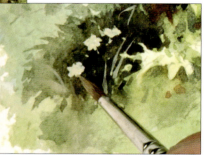

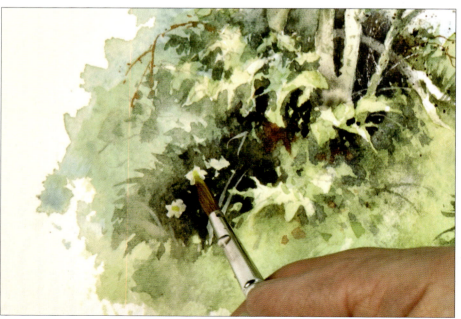

26 Paint cadmium yellow pale in the centres of the primroses while still wet.

The finished painting. It takes time and patience to build up a complicated section of uninhibited natural growth, with many features needing multiple layers applied in order to suggest the nuances of the various plants in and out of shadow areas. You will have seen how we need to restate passages that have not quite had the impact desired. If you feel daunted by this, try painting just the left-hand side of the composition.

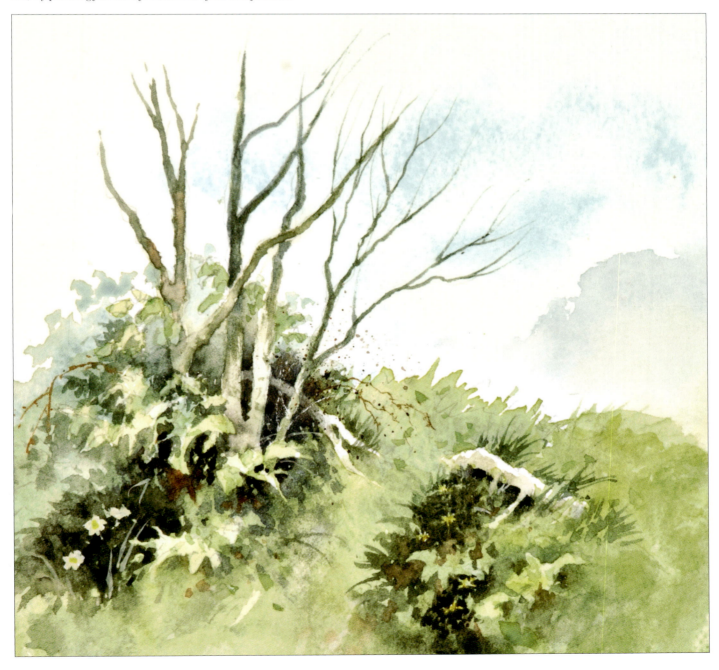

Landscape

Getting out and sitting in front of your subject to paint or sketch is without doubt the best way of learning to paint landscapes. I do realise though, that many artists are incapacitated, or for some reason cannot or prefer not to venture outside, and so have to rely on whatever source material they can obtain. Whatever source you work from you will find the methods described in this chapter of great benefit. If you have to work from old photographs, it is worth doing a sketch of the scene and observing all the nuances in the subject, so that the composition is clear in your mind before you settle down to the painting.

Working from nature

Working directly from nature will teach you so much, even if it is only your garden, the view from the window, or if you have to resort to taking snapshots or rapid sketches from a bus window. I am forever sketching from moving platforms, whether train, aircraft, boat, bus, dog-sledge, camel, or one of many other forms of transport, because there is so much to see out there, and with practice such rapid sketches can become a really effective means of acquiring subjects. The sketch of Grindon church, for instance, could be done in little more time than it takes to sit at the traffic lights waiting for them to turn green. Sure, I would have to fill in most of the tonal areas afterwards, and the sky would probably need to be completed as I hurtled along, but this is not always a problem even at great speed, as I have managed on occasion. So long as you are not doing the driving, of course!

The key to this is observation. Train your visual memory to work for you and learn to look for the important aspects in a view. Working at speed is exceptionally effective in developing this ability to remember important elements. Look for what excites you, whether it is a certain type of subject, the way light is playing on an object, perhaps a stormy atmosphere in distant mountains, or whatever. Start your drawing with that object and work outwards. Compare everything: how dark is that wall against the background? Where are the warmest greens? How big is the postman compared to the height of the door he is approaching? Will the building benefit from enlarging that bush to hide the ugly porch? This sort of self-questioning is invaluable in working out your response to a scene. Constant comparison really does sharpen up your observation.

Grindon Church, Peak District

This water-soluble pencil sketch is done on an A5 cartridge sketchpad. Firstly the drawing is done in the usual way, with the tone applied using the pencil dry. Then water is brushed over the image with a medium-sized round brush. This creates a lovely, atmospheric sketch.

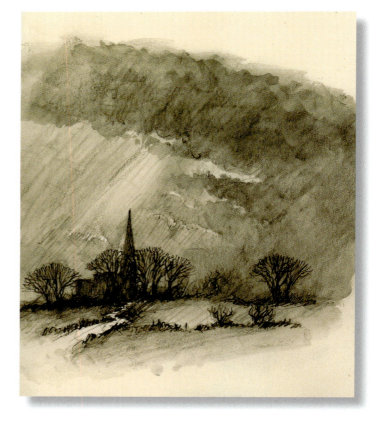

Putting your own stamp on a subject

Our compositions need to be simplified and modified from the actual landscape, otherwise we take on too much, might as well resort to a photograph and lose any sense of achieving a painterly response. The processes involved in developing a composition are outlined in the example of Bryntwppa Farm, stopping short of the actual painting. Firstly study the actual scene, which was photographed from a high ridge in the distance with a zoom lens, and then compare it with the sketch carried out on the spot. The scene has not only been simplified, but certain elements have been altered, such as the tones on roof and background foliage. Working only on an A5 sketchbook, I had no room to include all the details, so important ones such as architectural detail have been added in an inset in case they are needed later. Always think about how you want the finished painting to appear when working in the field. A studio sketch is not always necessary, but where there is any confusion, it can be really worthwhile, and the one illustrated here shows how I would tweak the painting with slight changes to improve the composition. When working on the painting, all these sources are important for reference, but by then you should be clear in your mind how you wish to proceed with the composition.

Photograph of Bryntwppa Farm

Pencil Sketch of Bryntwppa Farm

I looked down on the scene from some distance as I sketched, and once I had drawn the main features, I checked the scene through binoculars to get more architectural detail, although this is often a double-edged sword as it is usually best to keep things simple.

Studio Sketch of Bryntwppa Farm

A studio sketch is extremely useful where you want to experiment with the composition. Sometimes I do several before choosing the final version for the painting. Normally, however, when I sketch the scene on the spot, I automatically filter out irrelevant features and improve the composition. In the original sketch I reversed the tones of roof, chimneys and background trees, but I decided to revert to the original tones in the studio sketch and keep the buildings free of too much detail. I moved the closest tree to the left-hand side of the lane so that the lane is not too isolated from the farm, as it provides an excellent lead-in. The perspective problems were minimal when the buildings were viewed from this distance.

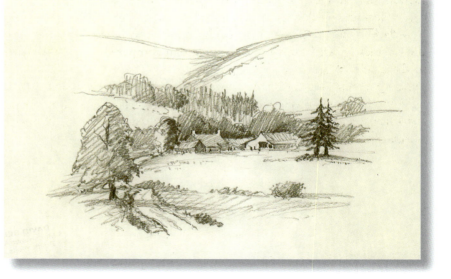

Painting from sketches and photographs

By reducing the amount of detail you see in a scene, you will give your composition more impact. Do this by leaving out unnecessary features or parts of features, cutting down on objects, such as putting in only three trees, say, where perhaps there are twelve, and also by taking a whole mass of background detail and painting it as a flat wash, using an approximation to the main colour you see in the mass. Looking at it with half-closed eyes helps to assess this. Another technique I use frequently is to paint in some of the detail (usually not all of it), then when the paper is dry, lay a transparent glaze across that part of the painting to subdue the detail, leaving some just about visible.

Photograph of the
Footbridge at Ashgill

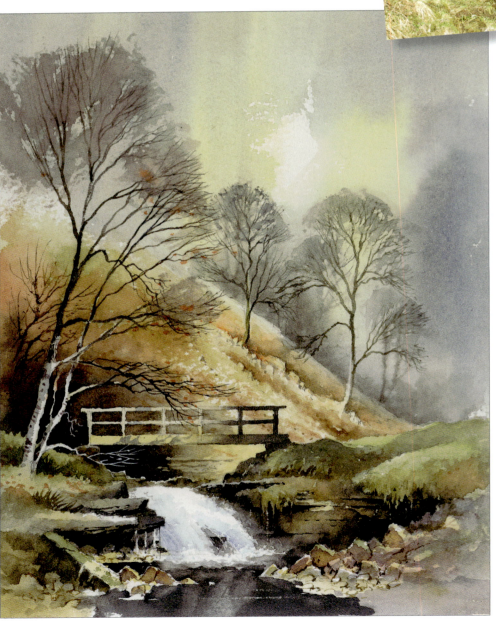

Footbridge, Ashgill
230 x 180mm (9 x 7in)

Compared with the photograph, the scene is much simplified. The mass of background trees and bushes climbing up the side of the gorge are greatly weeded out, the bridge has one less horizontal bar and the rocks and water are less detailed. It is a question of identifying the most important elements in a scene, then deciding on which supporting features to include and tossing the remainder aside.

Composing a landscape to highlight the focal point

Every composition benefits from a strong focal point, and this can be highlighted by placing the strongest lights against the strongest dark and perhaps adding the brightest colour on or next to this feature. Lines converging on the focal point also help to lead up to it. On this page we look at a mountain scene in Norway and how we can present alternative centres of interest, yet still retaining the main feature of the scene, i.e. the shapely mountain.

Photograph of the
Scene at Skottinden, Norway

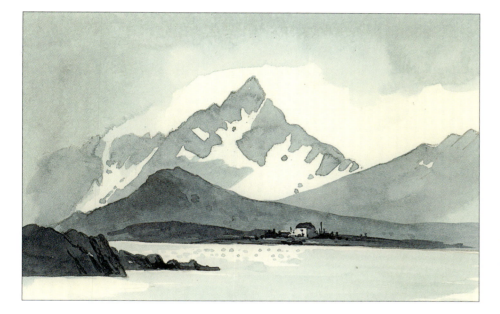

Skottinden – Studio Sketch, Version 1
150 x 230mm (5⁷/₈ x 9in)

This monochrome studio sketch shows the mountain with the building positioned as the centre of interest and strongly highlighted by use of contrasting tones. In the final painting of this view I would also use brighter colours beside the building to further establish it as the focal point.

Skottinden – Studio Sketch, Version 2
150 x 270mm (5⁷/₈ x 10⁵/₈in)

Using the same original viewpoint as the above version, I choose to move the building out of the picture to the right and replace it as a centre of interest with the small tree, rocks and sparkling water. In the painting I would enhance the colours by the tree and probably make the tree itself a little larger.

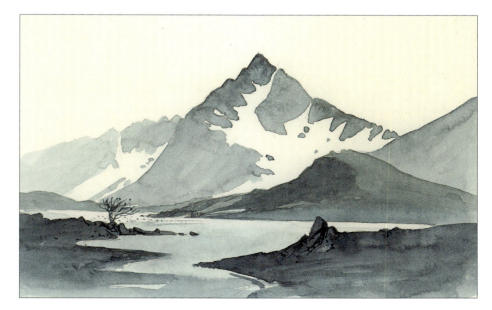

63

Creating a sense of space and distance

To achieve a sense of space and distance, we employ a number of methods. One of the most obvious is, of course, to make objects smaller as they recede. It does not matter if for example you have an occasional distant tree appearing larger than a closer one, so long as the main features follow this principle.

Aerial perspective is the method used by artists to suggest the effect the atmosphere has on objects that are nearer or further away from the viewer. This means that strong detail should be reserved for close objects, the detail diminishing as features become further in the distance. Colours lose their intensity with distance and become duller. Cooler colours, especially blues, greys and blue-greens, suggest a sense of space, while the warmer reds, oranges and yellows come forward. Placing the latter colours in the foreground will automatically push the rest of the painting further back. The same is true of tones, with the strongest normally being close to the foreground.

Naturally there are exceptions to these conventions, such as a distant mountain peak caught fiery red in a sunset, or a dark shadow over a crag some way away. In these cases make sure that you counter this by creating strong detail in the foreground, then if the distance peak is a warm red, ensure there are deep tones near the foreground, or if the distant mountain is really dark, apply warm colours close to the viewing point. You can assess these effects by producing small watercolour sketches featuring the above points.

Middim Khola, Nepal
200 x 280mm (7⅞ x 11in)

This watercolour sketch on a Not surface illustrates the river looking into the light, which enhances the sense of aerial perspective. See how the colours become cooler, or bluer, as they recede, and the tones become less strong. Here we are looking several miles into the distance, but this effect is worth exaggerating even on much closer distances in order to accentuate the depth.

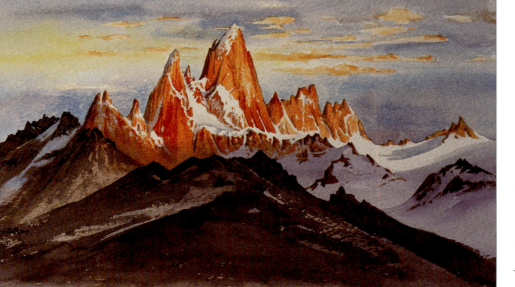

Mount Fitzroy, Argentina
215 x 310mm (8½ x 12¼in)

Caught in the light of a fiery sun rising over a mountain ridge, Fitzroy is ablaze with reds and oranges. The strong, dark foreground, however, pushes it back into the mid-distance.

Painting water

Water can be a challenge to render effectively. Reflections, turbulence, ripples, sparkling water and cascades all benefit from being suggested rather than described in great detail. Choose one or two reflections, ripples or rushes of turbulent water rather than featuring them all. The rest can be played down. This book is full of examples of many types of water. See the example of simple dry brush work on the River Usk on page 67, achieved with two or three quick horizontal strokes on Rough paper; the ripples in the Norfolk Wetlands scene on page 72, done with a 13mm (½in) flat brush; and the reflections in the puddle on page 73, applied with a no. 1 rigger while the puddle area was still damp. Simplest of all is probably the Afon Claerwen on page 71, where apart from a few little dabs of blue-grey applied horizontally, the river is effectively defined by the boulders and stones forming its banks; the rest is left as white paper. I suggest you try copying these watercolours using whatever colours you wish. Further examples of water can be found in the Coastal scenery chapter on page 114.

Painting a waterfall

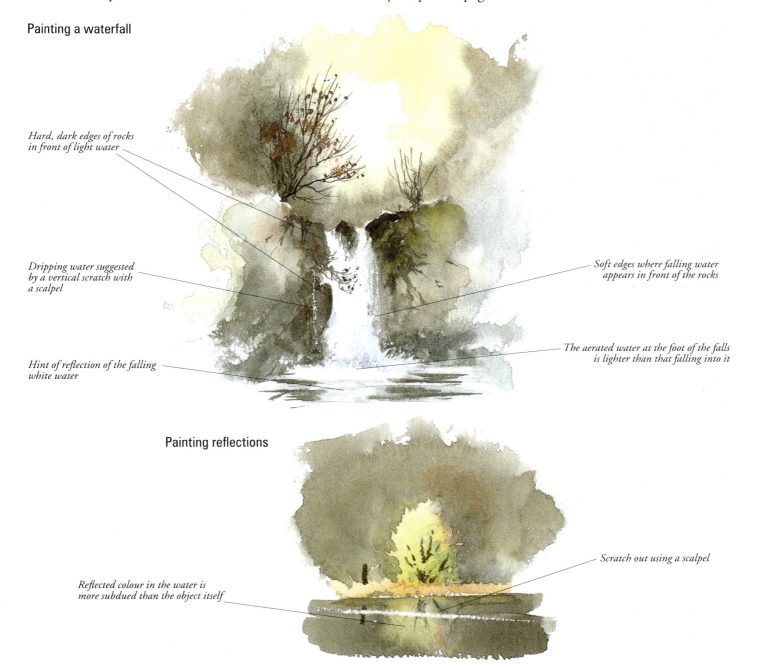

Hard, dark edges of rocks in front of light water

Dripping water suggested by a vertical scratch with a scalpel

Hint of reflection of the falling white water

Soft edges where falling water appears in front of the rocks

The aerated water at the foot of the falls is lighter than that falling into it

Painting reflections

Reflected colour in the water is more subdued than the object itself

Scratch out using a scalpel

Mountains and crags

This mountain scene covers many of the features you will encounter at mid-level in the mountains. Note how important it is to use light and shadow to bring out parts of the composition and subdue others.

Dark shadow on this peak both subdues any rock detail and throws the emphasis on to the closer crag

A sense of a summit hidden in cloud is created by running the grey wash up into a wet surface

Miniature pines by the waterfall push this part of the painting into the distance

Gullies can be suggested simply with subtle changes of tone

Scrubbing paint across the surface with the side of a round brush will suggest rough slopes

Vegetation provides a contrast to the hard edges of rocks

Note how a waterfall tumbles over a band of more resistant rock

The tops of rocks are often lighter than the surrounding vegetation, as they are more reflective

Dark rocks and boulders help to define the banks of the stream

Diagonal dry brush strokes are excellent for suggesting scree, especially when supported by a few individual dark blobs

Strong detail on foreground crags throws the rest of the scene into the distance

River Usk and Carmarthen Fan
100 x 210mm (4 x 8¼in)

Here the mountains are laid in with a simple flat wash, an effective method when the foreground or middle distance is busy. Do not feel you have to include any detail on mountain slopes.

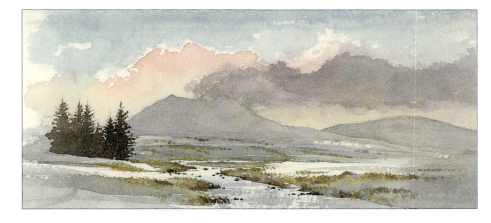

Note how snow lies compacted in gullies, sometimes long after the rest has thawed

Darker sky defines the snow-bound col

Mist on Hall's Fell Ridge
210 x 170mm (4 x 6¾in)

To give a sense of scale, it is helpful to include distant figures. However, if you place them too close to the foreground, they can give a false impression of size.

Painting trees in winter and summer

Well-pointed round brushes are important for painting winter trees, and for the smaller branches I resort to a rigger brush. It takes some practice to become accomplished at drawing with its long hairs, but it is worth the time spent practising. Work out from the centre of the tree as much as you can, turning the drawing board to suit yourself if you need to. Ease off the pressure on the brush as you approach the extremities of these branches. To achieve a really fine point, load the brush with colour, then drag it across a piece of scrap paper, twisting it around at the same time. Once you have your fine point, apply the paint.

Winter Trees
240 x 300mm (9½ x 11¾in)

For winter trees, I generally use a no. 4 or 6 round brush for the trunk – larger if it is really big – and a no. 1 rigger for the smaller branches tapering out to the ends. Here I use a mixture of French ultramarine and burnt umber, dropping a hint of cadmium yellow pale into the trunk while it is still wet. A sense of distance between the large tree acting as the focal point and those in the background is achieved by making the large tree bigger with stronger tones and sharper edges than the ones beyond. The sky is a good example of the wet-into-wet technique where the darker horizontal clouds across the centre are painted in while the sky wash is wet. This is done as the sheen is beginning to leave the wet sky with very little water on the brush – only fairly strong paint.

Avoid the tendency to create muddy effects in summer foliage by keeping your washes clean and applying them with as few strokes as possible. If you add further colours for shadows, whether into wet or on dry paper, try not to keep pushing the colour around, as this will cause mud. Work out from which direction the light is coming and apply any shadows to the other side as well as underneath the main mass.

Summer Trees in a Hayfield
150 x 250mm (6 x 9¾in)

Summer foliage is often best rendered by painting with the brush on its side, working from the outside edge of the foliage into the centre. This painting is done on a Not surface, but the technique works really well on Rough paper as you can achieve natural gaps in the foliage with less effort. With summer trees I usually include at least a part of the trunk and some branches, even if I cannot see any, as this gives structure to the tree. Where the branches disappear up into the foliage, drop in some shadow – this makes it look more natural, but try not to scatter little portions of shadow all over the foliage, as this spoils the effect, even if that is what you actually see on the tree.

Tree trunks

Where you have trees fairly close to the foreground, try describing some detail on their trunks. As well as adding interest, this can identify the species, as with the Birch trunks example. I often inject rogue colours into trunks, hedgerows and the like. These are colours which I feel would enhance the feature even though they are not really there. Reds and oranges especially come to mind.

Painting a tree trunk

In watercolour it is easy to end up with muddy brown trunks, but look closely for other colours and note also how the light affects the trunk. Here I leave some white on the trunk to suggest strong sunlight. The main parts are painted with a mix of cobalt blue, cadmium red and a touch of yellow ochre, with some orange dropped in on the left-hand side. The dark shadows are achieved with burnt umber and a little cobalt blue.

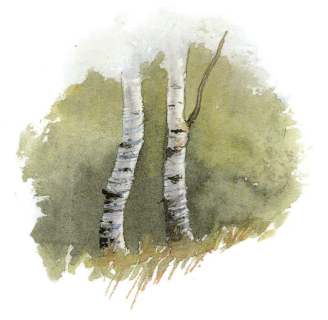

Birch trunks

These are so distinctive, and here I want to emphasise the importance of trying to capture a likeness to particular trees, whatever species. First the outlines are defined by painting the dark grey-green wash behind, then wetting the area of the trunks with clean water. I run a brush loaded with French ultramarine and a little permanent alizarin crimson and hardly any water down the centre of each trunk. This creates a shadow area in the centre, softening out towards the edges, a common feature with birches. With a fan brush I suggest the rings around the trunks with cobalt blue and hardly any water, then a few strong dark spots with a no. 4 brush.

Massed trees

I begin with a flat wash of the general colour of the massed trees, often dropping in colour variations, but without strong contrast if they are in the distance. Sometimes I overlap a second wash with a similar colour and a change in tone, to suggest a few examples of half-seen tree detail. At the edge of a tree mass I usually describe one or two prominent trees, and this has the effect of suggesting the rest of the mass. See the background mass of winter trees at the top of the opposite page.

Foregrounds

Careful thought should be applied to constructing your foregrounds. In a landscape, this is where you see detail in close-up, and overworking here can cause muddy and fussy passages. These four examples of the main types of foreground will suggest ways to tackle various situations.

Leicestershire Landscape: the simple foreground

140 x 200mm (5½ x 7⅞in)

With the focal point in the middle distance, the foreground here is extremely simple, merely a wash of Naples yellow with some splashes of yellow ochre and a few blobs of cobalt blue and burnt umber dabbed in to suggest cart tracks leading to the main tree. This is a useful foreground where the focal point is in the middle distance or that part of the composition is busy. If you are tempted to add further detail, put the painting away for a few days then review it with a fresh eye.

Cotswold Fields: the detailed foreground

190 x 250mm (7½ x 9⅞in)

The dry stone wall and vegetation in the bottom right foreground push the rest of the composition further away. Try not to overdo the detail, however, as it can become overwhelming if taken right across the foreground. If you want to throw more emphasis into the distance, lay a shadow across the foreground detail. This type of foreground is excellent for creating depth in front of the middle distance, or even for creating the focal point in the foreground itself. Text books will tell you not to overwork foregrounds, but if you enjoy painting intense detail, do not let them spoil your fun. But be warned – it is not good practice.

Afon Claerwen: the vignetted foreground

190 x 140mm (7½ x 5½in)

This method of just defining a few stones, grasses or flowers, works really well where there is a lot of repetitive detail in the foreground. It is not necessary to paint in every pebble as it can become visually boring. Another vignetting technique is to put in a little more detail, then when the paper is dry, gently sponge the edges with clean water to create a soft edge, rather like the old Victorian photographs.

Misty Gorge: a semi-abstract foreground

200 x 140mm (7⅞ x 5½in)

When you are confronted with a jumble of foreground objects, such as the detritus of a mine where just about everything has been thrown out, an abstract or semi-abstract foreground can be the answer. In this case I retain some of the boulder shapes and the small cascades, but on the right I scrape red paint across with a piece of old mountboard and dab the edge on the paper once or twice. In the bottom left I dip one of those miniature net bags that come with washing powder into blobs of French ultramarine and burnt umber and press this on to the surface of the paper to create a pattern. Whatever you decide, try basing the shapes on some of the objects lying around, and experiment with various colours and patterns. Experiment with these abstract methods on paintings where the foreground has been an abject failure.

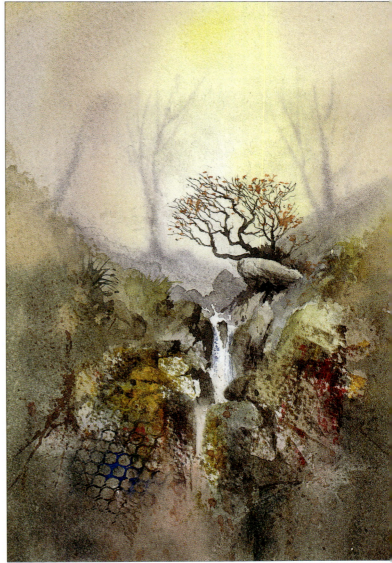

Skies, light and atmosphere

It pays to consider the type of sky that will suit the landscape you intend to paint, and this will affect the overall light and mood. Time of day will also need to be considered, as warm evening light can impart a quite different atmosphere from that at midday. Soft-edged clouds can be done wet into wet, while hard-edged ones are achieved by painting on dry paper, though the edges away from the sunlight should be softened with a damp brush, or perhaps even lost completely. Sketch and photograph different skies as you come across interesting ones, and these can form a reservoir for when you need a certain kind of sky. Study the various examples of skies in this book.

Always be aware of where the light is coming from, in order to keep your shadows constant and not at variance with one another. Remember, you can intensify light by placing darker, more ominous shadows beside it. Transparent yellows are excellent for suggesting warm sunlight, but also leave pure white paper in places, as this really does give a powerful sense of an object caught in the light. The tree trunk on page 69 is a good example of this technique.

Border Skyscape

This watercolour sketch shows a sky painted in two stages: firstly the cobalt blue which defines the tops of the clouds is painted, and immediately a light grey mixed by adding cadmium red to the blue is put in below. When all this dries, a stronger mix of the same colours is laid lower down the sky with hard edges at the top. This wash is taken down over the hills below, which are then painted in wet into wet with a dark version of the same mixture. This relates sky and land well.

Sunset Over the Norfolk Wetlands

210 x 310mm (8¼ x 12¼in)

The sky is built up gradually. I begin with a thin band of cadmium yellow pale across the central area, leaving a soft-edged white patch in the middle, then bring a mixture of cobalt blue and cadmium red down from the top of the sky to just touching the yellow to blend it in. When this is dry, I paint cadmium yellow deep across the left-hand band, leaving a strip of the earlier yellow to show, and after wetting the lower sky drop some cadmium orange into it. The next stage is to lay horizontal strips of the cobalt blue-cadmium red mix across the lowest part to define the far side of the water, and take it up to describe clouds on either side. A suggestion of a band of trees on the far side of the water is inserted wet into wet with a stronger version of the same mix. Skies like this benefit from a little thought beforehand.

Early Morning, Denshaw

This small watercolour sketch, done on cartridge paper shortly after the sun had risen above the horizon, took about ten minutes, and captures the essence of a crisp Pennine morning in February. Most of it is a mixture of cobalt blue and burnt umber with touches of yellow ochre in the foreground. The buildings are simple because that is the way they appeared. Half an hour later I could see far too much detail and the lovely atmosphere had evaporated.

Glazing and wet into wet

Strong atmosphere can be suggested by laying a transparent glaze across the painting, or part of it where the mood is at its strongest. Use transparent colours like French ultramarine to cool a passage and permanent alizarin crimson or permanent rose to warm it up. Try other colours as well, but the more opaque ones are likely to create mud. Make sure the passage is absolutely dry before doing this and use as few strokes as possible with the largest practicable brush. Rough paper works best for glazing, as you touch less of the surface. This is a risky technique so I suggest you gain experience first on old paintings that have not worked for you.

The wet-into-wet method is also excellent for creating a sense of atmosphere, whether over the whole painting or just a small part. It is especially effective when employed as a backdrop to a feature rendered in strong tones and sharp edges that form a complete contrast to its softness. I often begin with masking fluid over a feature and then apply the wet-into-wet passage over this, thus creating a sharp contrast. The Boat at Buckler's Hard on page 119 is an example of this method.

Heathland at Torridon
200 x 180mm (7⁷/₈ x 7¹/₈in)

Both mountain ridges were painted in after the sky with its lowering clouds and its hint of brightness created with Naples yellow. All this was allowed to dry thoroughly before a glaze of Winsor blue and cadmium red was washed across the sky and mountains to bring it all together as a moody backdrop.

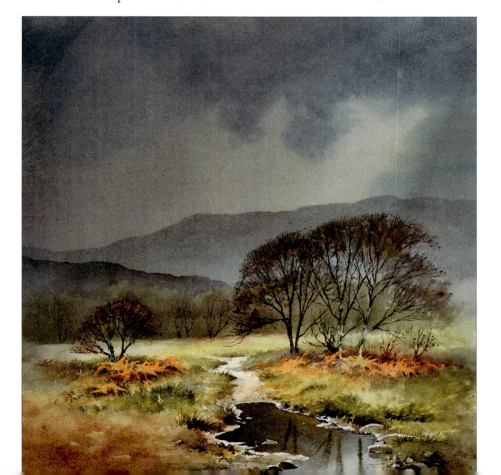

River Landscape

In this demonstration, we will cover many of those features so fundamental to landscape painting: trees, a river, distant mountains and cattle.

YOU WILL NEED

640gsm (300lb) Not paper

Colours: new gamboge, alizarin crimson, cobalt blue, French ultramarine, cadmium red, cadmium yellow pale, yellow ochre, light red, burnt umber, burnt sienna, Naples yellow, white gouache

Brushes: no. 7 round, squirrel mop, 13mm (½in) flat, no. 8 round, rigger

Scalpel and pencil

1 Draw the scene.

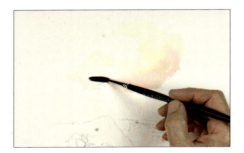

2 Pick up new gamboge on the no. 7 brush and scrub it across the centre of the sky to create a ragged edge. Drop in alizarin crimson while this is wet and feather it out into the first wash. Allow to dry.

3 Paint cobalt blue into the top left-hand side of the sky using the squirrel mop. Blend it into the already laid colours with clean water.

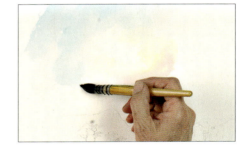

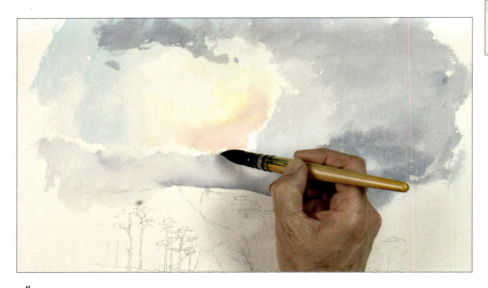

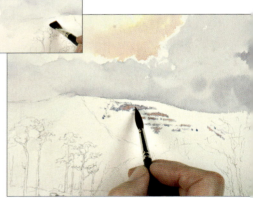

4 Paint ultramarine and cadmium red in the lower sky, starting just short of the pink and yellow paint and going down to the snowy mountains.

5 Soften the left-hand edge of the white mountain using a damp 13mm (½in) flat brush. Change to the no. 7 brush and use the ultramarine and cadmium red mix to paint the mountain crags. Drop in cadmium red while wet to warm the colour.

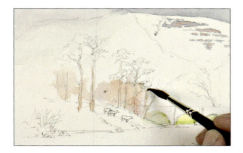

6 Paint the background under the bridge using cadmium yellow pale, and drop in cobalt blue while wet, then yellow ochre. Mix yellow ochre and alizarin crimson and paint the tree trunks on the left and the area behind them.

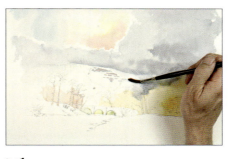

7 Paint yellow ochre on the right-hand side of the mountains. Allow to dry. Wash clean water over the lower sky and right-hand snowy mountain ridge with the squirrel mop and immediately brush a weak mix of ultramarine and cadmium red across this area with a no. 7 brush, to suggest a squall coming down over the ridge. Note that the wash should not go further than the limit of the wet area, otherwise a hard edge will form.

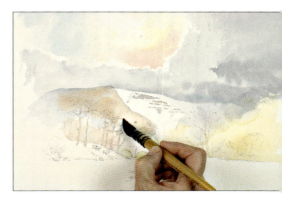

8 Change to the squirrel mop to paint the snowless peak on the left and the pines with the ultramarine and cadmium red mix. Drop in light red while wet and allow to dry.

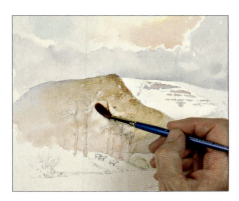

9 Use the no. 8 brush and a mix of light red and burnt umber to paint the left-hand peak with the dry brush technique. This allows the wash underneath to show through and creates texture.

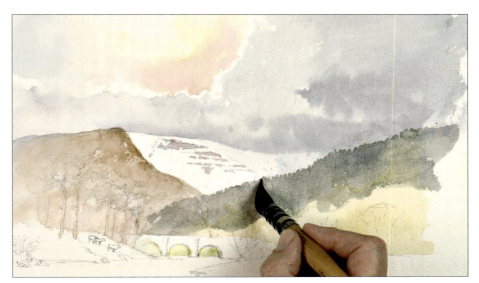

10 Create a mixture of ultramarine and cadmium red and drop a little yellow ochre into it. With a squirrel mop, apply this over the wooded hillside running down from the right. Here you see the brush being used to dab into the top edge to suggest the tops of massed conifers.

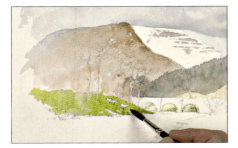

11 Hint at detail behind the bridge with the same mix. Paint the left-hand bank with cadmium yellow pale and French ultramarine, with yellow ochre dropped in in places for variation. Drop in cadmium yellow pale to suggest a hint of sunlight.

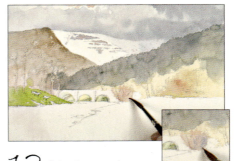

12 Paint the area of trees on the right-hand side with yellow ochre and drop in alizarin crimson in places to warm it and to add a bush by the bridge. Drop in ultramarine while wet.

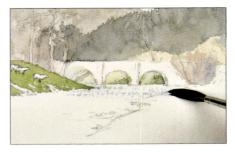

13 Load the no. 7 brush with French ultramarine but with little water and drag it dry brush fashion across the river horizontally beneath the bridge.

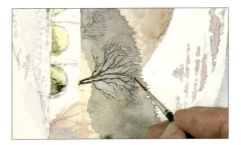

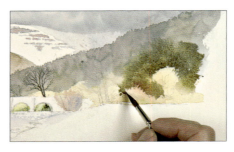

14 Turn the painting to get a better angle for painting the tree. Bring the rigger brush to a fine point and pick up ultramarine and burnt umber. Paint the tree, working outwards from the centre.

15 Wet the right-hand side of the painting. Mix burnt umber and a touch of ultramarine and paint round the light-coloured tree and bush.

16 Use a stronger mix of the same colours and negative painting to paint the tree. Drop in light red while wet to vary the colour.

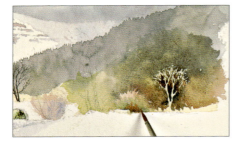

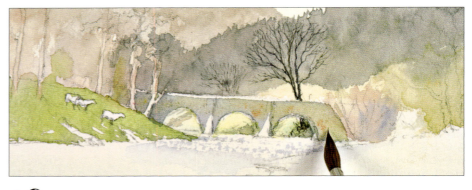

17 Use the no. 4 brush to wet the light-coloured bush, then paint the underside with burnt umber and ultramarine. Drop in light red.

18 Paint the bridge with the no. 7 brush and the sky mix of ultramarine and cadmium red, leaving the top and the sunlit parts of the buttresses white. Drop in yellow ochre while wet, then light red.

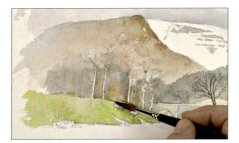

19 Paint between the trunks of the pine trees with ultramarine, cadmium red and yellow ochre. Drop in light red while wet.

20 Paint the shadowed details of the bridge buttresses with ultramarine and cadmium red. Allow to dry.

21 Use the same mix to paint some of the bushes in the background. Paint the details of the lighter bush beside the bridge with burnt umber and the dry brush technique. Paint the right-hand side of the bush with a strong, dark mix of burnt umber and ultramarine.

22 Use the no. 4 brush and a wash of ultramarine and cadmium red to darken the left-hand side of the bridge, and to paint cast shadows from trees across it.

23 Use the same shadow mix to hint at distant trees beyond the pines on the left-hand side.

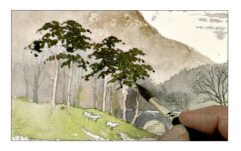

24 Mix a strong, dark green from new gamboge, ultramarine and burnt umber and use the no. 7 brush to paint the foliage of the pines.

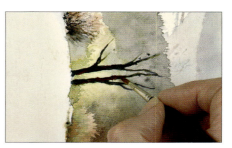

25 Use a mix of ultramarine and burnt umber and the no. 4 brush to paint the trees on the right of the bridge. Turn the board to help you. Drop in raw umber, then cadmium red while wet.

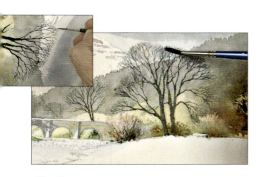

26 Paint the fine branches with the rigger and the ultramarine and burnt umber mix. Turn the board again and use the no. 8 brush to paint the twigwork with the sky wash of ultramarine and cadmium red.

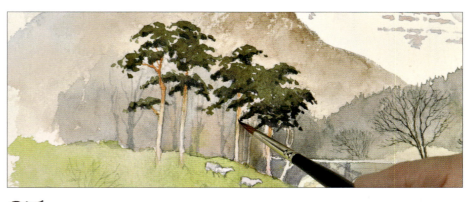

27 Paint burnt umber and French ultramarine on the darker side of the pines with the no. 4 brush. Paint the tops of the pine trunks with burnt sienna.

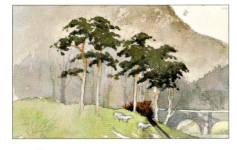

28 Paint the bush on the left of the bridge with burnt sienna. Touch in burnt umber and ultramarine at the bottom while wet.

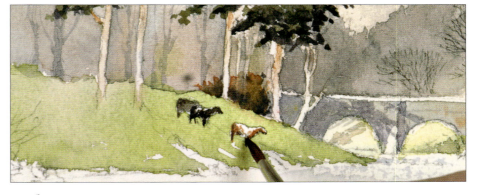

29 Paint the cows, one with burnt sienna and the other with ultramarine and burnt umber.

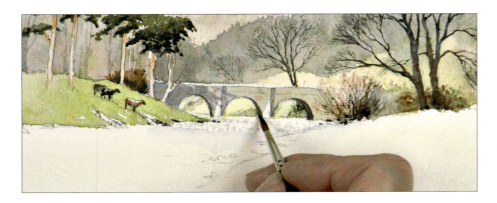

30 Paint some distant rocks in the water with burnt umber and ultramarine, then paint the shadow under the arches of the bridge.

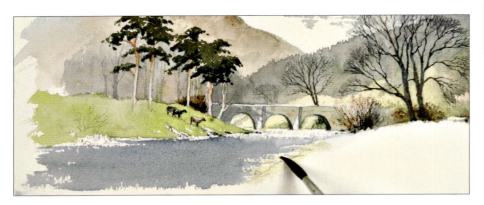

31 Use a fairly dry no. 7 brush and a mix of ultramarine with a touch of burnt umber to paint across the water. Paint Naples yellow for the river bed where the river is shallow.

32 Load the rigger brush with Naples yellow and white gouache and work on the right-hand tree that was created by negative painting. Paint the field on the right with a mix of new gamboge and cobalt blue on the squirrel mop.

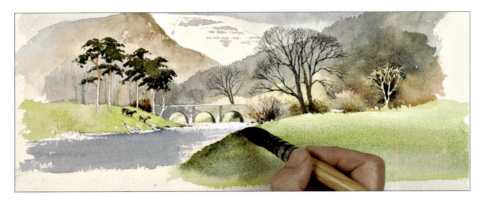

33 Drop in raw umber and ultramarine while wet and stroke it across the edge of the river bank.

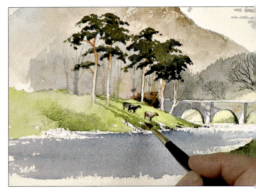

34 Use the same mix and the no. 4 brush on the opposite bank to paint shadows.

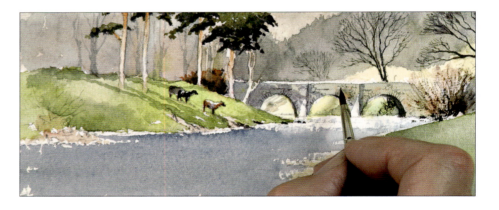

35 Mix yellow ochre and alizarin crimson to paint the sandstone rocks at the river's edge. Paint the texture of the stonework on the bridge with ultramarine and burnt umber.

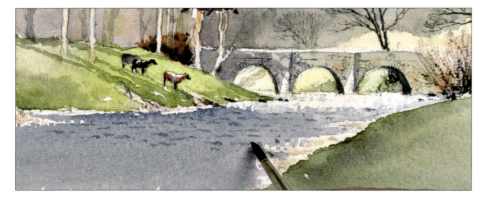

36 Paint the ripples in the water with the sky mix of ultramarine and cadmium red using little horizontal strokes, making them larger as they come further forwards.

37 Paint a bush on the left with burnt sienna, and drop in burnt umber and French ultramarine while wet.

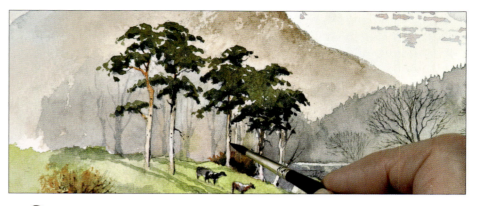

38 Bring the no. 4 brush to a fine point and use a dark mix of ultramarine and burnt umber to darken the tree trunks and branches where they are in shadow under the foliage.

39 Paint more burnt sienna on to the pine trunks. Use the rigger brush to paint a bare tree above the bridge with ultramarine and burnt umber. Suggest the branches and twigwork of the bushes in the same way.

40 Take the scalpel and scratch out white flecks for highlights on the water.

41 Use the 13mm (½in) flat brush and a mix of ultramarine, cadmium red and new gamboge to stroke across the right-hand field with the dry brush technique to create broken colour.

The finished painting. The snow-covered ridge is considerably higher than the warm left-hand peak and this is how the scene looked when I did the original sketch. It might have been worth making the left-hand peak appear under snow as well, simply to suggest continuity, but this is an individual choice. Softening distant ridges with a squall can be a very effective way of subduing part of the picture.

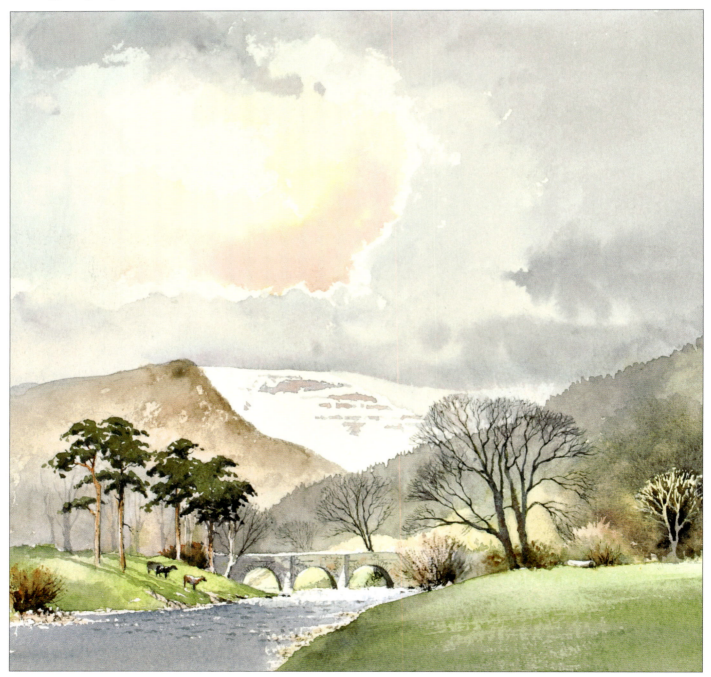

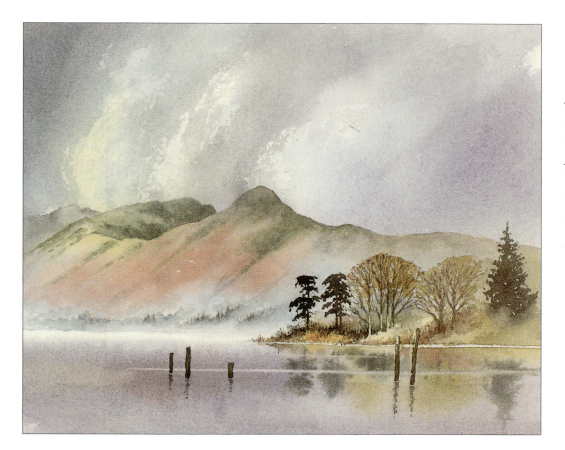

Catbells and Derwentwater
180 x 210mm (7 x 8¼in)

Morning mist lies across the lake, so thin that only against the more distant features does it become apparent. To achieve this effect, soften off the bottoms of the distant conifers, touching in a hint of weak blue, then juxtapose against this a strong, dark feature such as the Caledonian pines seen here on the edge of a nearby island. To draw the eye to these as a focal point I paint in some warm colours at the base of the trees.

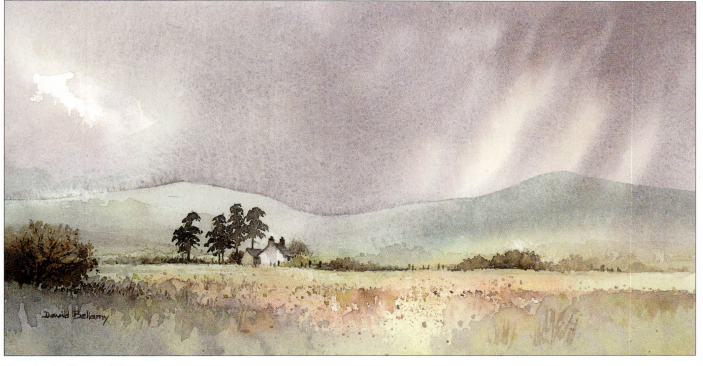

Farm in the Eppynt Hills
145 x 270mm (5¾ x 10⅝in)

A useful technique where the background hills lack interest is to introduce counterchange as in this scene. The hill to the left stands light against a slightly darker sky, while the one on the right is dark against a lighter part of the sky. The foreground grasses have been suggested with dabs and spatter which keep it lively compared with the flat washes on the hills.

Buildings

Whether a humble moorland hovel, rustic barn or an ostentatious example of classical architecture, a building can form a fine centre-piece in a composition. Many artists fill the paper with the building, thus creating a portrait of the place, but in this chapter it is seen more as part of the composition, normally the focal point.

Distant buildings

Buildings in the landscape make fine centres of interest. With more distant buildings any perspective problems are diminished and the building is viewed in its setting. You will observe many hard, straight lines on and around the building, but if you include all these it can detract from the painterly quality for which we strive. Break these lines up with foliage, flowers, figures, or simply losing the edge as you can see on the opposite page. Make the building look as though it is growing out of the ground by leaving out any strong bottom line, and this can be further enhanced by dragging the ground colour up into the walls of the building. This can be effectively carried out while the wall wash is still wet.

Farm by Carn Rhosson

This pencil sketch illustrates how a building does not have to be shown large in order to become the centre of interest. Distant buildings can make excellent subjects and of course the perspective is so much easier.

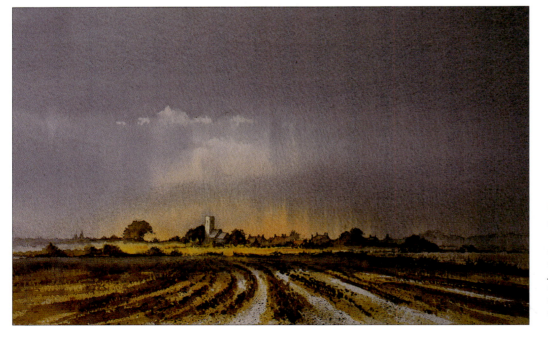

Sea Palling, Norfolk
250 x 480mm (9⅞ x 19in)

The interplay of sunlight and shadow throws emphasis on to the distant village, with the furrows leading nicely towards the church. The houses are less prominent, being in a supporting role.

Losing unwanted detail

If you record every window, every window-pane, every brick or stone, and so on, the result will look too busy and less like a painting. Paint in every bar of a five-bar farm gate if you wish, but I rarely put in more than two and a half bars. Try it in a painting and see which you prefer. Lose some of those windows, hint at only two or three panes per window if you have to include them. Smudge the edges with a damp brush to lose the detail naturally – this is very convincing on a stone wall where you do not want the detail to end suddenly. In villages, towns and cities where buildings back on to one another lose detail of one house as it goes behind another, thus creating a sense of depth.

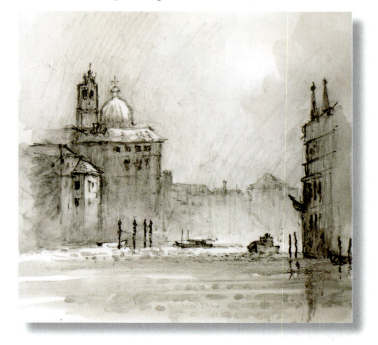

Grand Canal, Venice

Losing a lot of architectural detail lends a sense of depth to this pencil sketch, especially where the loss of detail is juxtaposed against dark tones of closer features such as the dark right-hand building and the posts. A water-soluble pencil was used for this sketch and much detail has been omitted even though I could see it quite clearly. As this was done from a moving boat, the sense of urgency this induced was a prime motivator for keeping it simple.

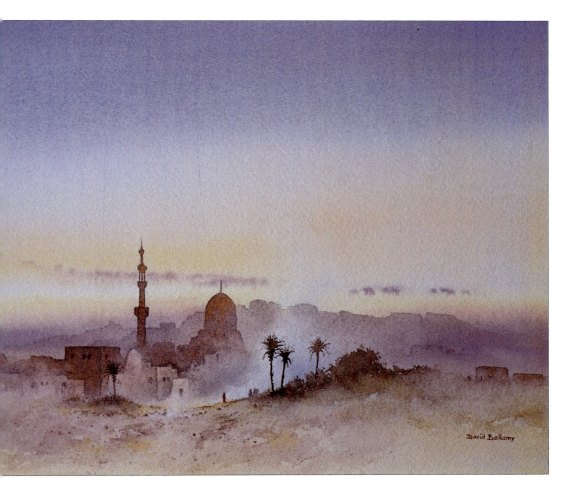

Tombs of the Caliphs, Cairo
205 x 310mm (8 x 12¼in)

I have omitted several other buildings and used the rising smoke to lose parts of the scene and to highlight the figures and palm trees. Most of the buildings are far enough away or wreathed in atmosphere, so the cardboard-cutout effect works well to simplify matters. Only two have a sense of three-dimensional solidity. From time to time you will see this flattened effect on buildings – the secret is to employ it as a painting device to improve a composition even when the effect is not present, as it really does simplify features that threaten to become too elaborate.

Capturing local character

Once we have acquired the basic skills for painting a watercolour we need to inject local colour and character into a scene. In the landscape this is most strikingly represented by the type and character of the local rock. The red sandstone of the northern part of the Brecon Beacons in Wales contrasts strongly with the limestone band further south, and this is reflected in the local architecture. The same will probably be true of wherever you live and paint. On this page are three buildings from various parts of England showing different styles of building, which put across the local character. Spotting these characteristics is an interesting exercise, as despite modern building methods, this is still apparent in the older buildings.

Pennine Farmhouse

There is a sense of solidity about Pennine houses, built to weather the wild elements of upland Britain. These are characterised by walls of attractive stonework, and huge slabs of mellowed gritstone on the roofs, often with more than a hint of green. The temptation to draw in every stone and tasty morsel of roof slab is great, but resist this, putting in a few suggestions of stonework as I have done. For good measure I have added a Swaledale ewe in the foreground to reinforce the local character.

Timber-framed Cottage, Worcestershire

The ripple of wonkiness in these old buildings is lovely to emphasise in any painting. Warm-coloured roofs, a sort of dirty red, and chimneys that appear to have been added on as an afterthought usually feature in these dwellings. This specimen has an unusual chimney at the right-hand end, where one of the chimney corners abuts the gable end. Take care not to make the black woodwork too intensely black and make full use of the white walls.

Lincolnshire Farmhouse

This brick-built house has clearly been altered over the years, as can be seen from the gable end where the later yellow bricks suggest an extension. While it is not vital to show this in a painting, it can add authenticity. Mansard roofs are widespread in these parts, and the original shape betrays this. Tall chimneys and a slate roof are also common with this type of building. Having the window directly below the chimney is unusual and means the chimney is not straight up the wall.

Line and wash

Ink outlines combined with watercolour washes are an attractive way of creating a pleasing painting, and this can be done in a variety of ways. While you can use this technique on most subjects, the method particularly lends itself to buildings. There are three basic ways of approaching this fascinating technique:

Firstly, you can draw in the outline in ink – or if you lack confidence, use pencil first, then ink over the pencil lines and erase them where they show. Then paint over the drawn image in much the same way as with normal watercolour, working from light to dark tones.

The second way of working is to outline the ink image as above, then add tone by cross-hatching with the pen, building it up slowly. Once it is dry, you can lay weak watercolour washes across the paper. You will not normally need to apply stronger tones as this has already been done at the inking stage.

Thirdly you can paint the picture in watercolour and when it is dry, draw over it with the pen, adding cross-hatching if needed. You need a lot of confidence for this version, but it is an excellent way of saving a painting that seems to have lost its way – usually because it lacks strong tonal contrasts. Try this out on your failed paintings – something we all have in common!

For line and wash you can use a fibre-tipped pen, a technical pen, or, best of all a dip pen with a pot of Indian ink. With the latter two types you will need a smooth paper surface, such as hot-pressed watercolour paper or good quality cartridge paper. A fibre-tipped pen is usually quite happy on a Not surface. You can also draw with pen-brushes where you have considerable variation in the thickness of line according to how much pressure you apply, and these work well even on a Rough surface.

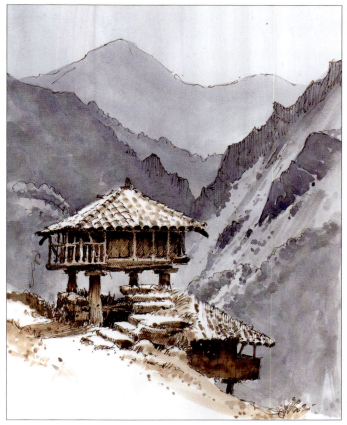

Piguena, Northern Spain

This line and wash sketch was done on smooth cartridge paper using a technical pen with an extremely fine nib. Lots of hatching was used to create tones. I laid on different planes of colour washes to suggest depth: French ultramarine and burnt umber for the distant features and burnt umber for the buildings and foreground.

Cottage in the Black Mountains

The drawing above, done on the spot, is rendered in ink with strong hatching in places where the dark tones appear. Colour washes are applied over the ink drawing (right), and although in this case I include some darker patches of green than the light green washes, the tones of the original line drawing are enough to give a strong impression of the scene.

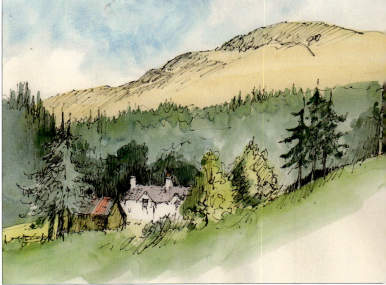

Linear perspective

Many people are confounded by perspective, but it is important to grasp the basics, especially if you are keen on drawing buildings. Here we will take a brief look at those aspects of perspective that will give us a reasonable understanding of how to tackle it. Firstly, it is important to realise that as you move around, to right or left, climbing up or down, you will significantly change the perspective of the object that you are observing. The first thing you need to establish is your eye level. This is an imaginary horizontal line that you project onto the object where it is level with your eye. If you are looking up or down a hill that line may well be considerably lower or higher than the building.

One-point perspective occurs where the building stands directly in front of you centrally and only the side visible to you is subject to the laws of perspective. Two-point perspective is brought into play when we view a building from one of the corners, that is, the nearest point to the viewer. Both visible faces are then subject to perspective rules. You need then to work out where your vanishing point will be —one vanishing point for one-point perspective and two for two-point. Establish the nearest vertical line on the building and mark the positions of the line of the eaves and the ground along this line, taking into account the scale you wish to work to. Repeat this with the vertical line representing the far end of the building, and then link these vertical lines by drawing in the line of the eaves and that of the ground level. If your eye level is part-way up a building the line of the eaves will descend as it goes away from you, and that of the ground rises as it goes away. Lightly extend these lines until they intersect your eye level somewhere in the distance. This will be your vanishing point. Rarely will it be accurate enough so that both converge at the same point, so you will need to slightly adjust one so that it meets the other at the vanishing point.

From the vanishing point you can then draw lines that show where the top of the roof will appear, and less obvious lines such as the top and bottom of doors and windows, and so on. Then apply the same methods to the second vanishing point. Note however, that in many old buildings the perspective is not always absolutely correct and then you have to decide between either 'correcting' it or retaining the character that such buildings always seem to exude. You may find that the transparent plastic templates sold as 'perspective finders' will make this process easier for you.

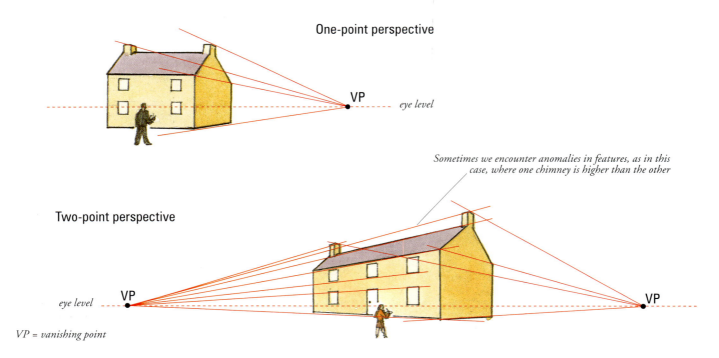

One-point perspective

VP *eye level*

Sometimes we encounter anomalies in features, as in this case, where one chimney is higher than the other

Two-point perspective

eye level VP VP

VP = vanishing point

Complicated perspective

Looking down a steep street or at a building perched high above you on a hill can cause complicated perspective problems. Again, it is vital to establish the eye level and vanishing points and work lightly with the pencil until you are confident that all is in its proper place. Whether you are looking up or down, the further the lines get from the eye level the more acute they become. To illustrate this find a tiled or brick wall and place an eye close to one of the lines of mortar or grouting between tiles. You can immediately see how those lines above your eye appear to go downwards as they recede, with the opposite effect for those below your eye level. If you shift your eye level to a point low down or high up you will see how acute are those lines furthest away.

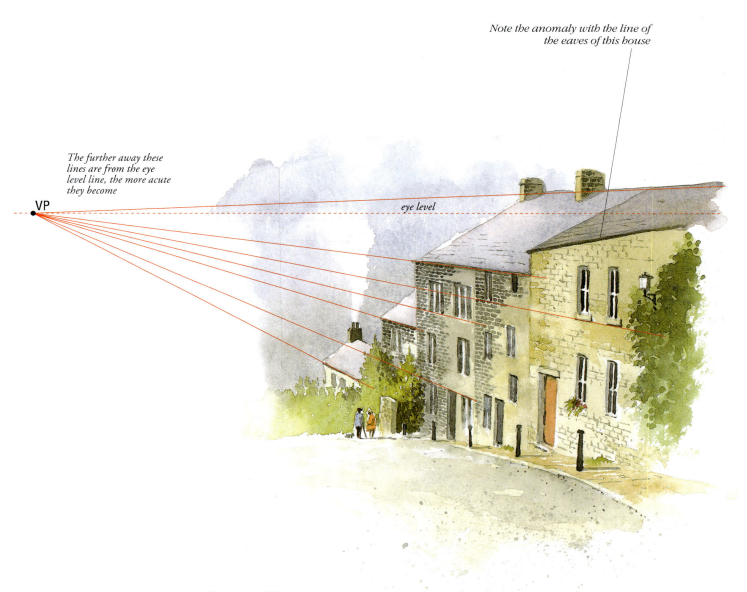

Note the anomaly with the line of the eaves of this house

The further away these lines are from the eye level line, the more acute they become

VP

eye level

Dobcross Village

To suggest the effect of looking down a steep street care is needed to establish the high eye level and then calculate the position of the vanishing point which of course is common to all the horizontal lines running in the same plane. Note how the lines radiating out from the vanishing point run along not just the line of the eaves and ridge of the roof, but the tops and bottoms of doors and windows. However, in old buildings you will find the actual perspective is out of line in some cases, as is clear with the line of the eaves on the right-hand house.

Village scenes

It pays to include people in any paintings of villages, towns or cities, otherwise the effect can appear ghostly. People should be doing things, not just standing around. Include cyclists, prams, people carrying things, looking at notice-boards, or whatever you wish. Try to include vegetation where you can to break up lines and create the opportunity for using new colours, and as always place more emphasis on those buildings that you wish to stand as the focal point, subduing the others as appropriate. Smoke is also useful for hiding unwanted detail, with the added advantage that it suggests life. Name-boards over shops or on vans can add colour, humour or a sense of place if you are creating a portrait of a particular village.

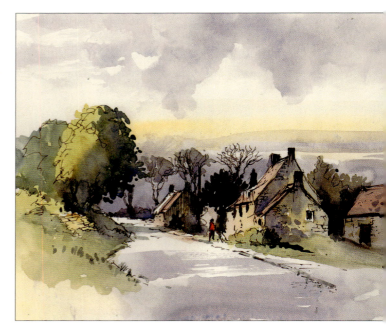

Sneaton Village, Yorkshire

In a village scene pick on one of the more handsome buildings and include the others in a supporting role. Wherever you can try to break up the hard lines with the softer edges of foliage as in this watercolour sketch. Include a few figures, otherwise the place does not looked lived-in. These need not be large. Position them near the main building and avoid surrounding them with strong detail.

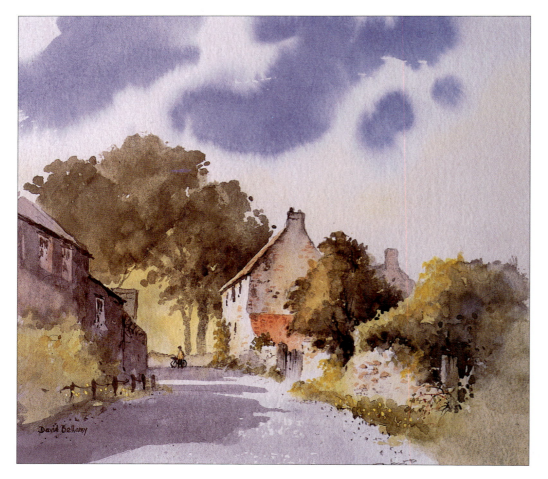

David Bellamy

Worstead, Norfolk

230 x 230mm (9 x 9in)

Vegetation is useful to break up the hard lines of buildings and also to introduce variation. Without figures any village scene will look like a ghost town.

Industrial subjects

Industry can provide fascinating subjects, and even grime and dirt can enhance a scene in the right light. Smoke, dust and light should be used creatively to lose or enhance features within the industrial subject. Smoke in between objects can create depth as well as losing edges and providing a strong contrast to some of the hard lines. The pit-heads of coal mines, tall factory chimneys and the like can make evocative backdrops in mining villages and factory towns, without having to render much detail, and they certainly give the scene a feeling of character.

Sfax Phosphate Factory

Industrial scenes often make interesting subjects, and here I have used the railway lines to lead in to the centre of interest. The less interesting or repetitive parts can be lost in smoke or use counterchange, as in the top left-hand corner of the factory which is dark, graduating it to the right. In a finished painting I might break up that long roof line with smoke.

Abercwmboi Coke Works
190 x 260mm (7½ x 10¼in)

Long since pulled down, this works was an amazing sight – and smell. The many sources of smoke created a constantly changing view so that the smoke could hide whatever you did not want to include. Stronger images of industrial detritus closer to the foreground suggest a sense of depth when set against the soft smoke and half-seen background.

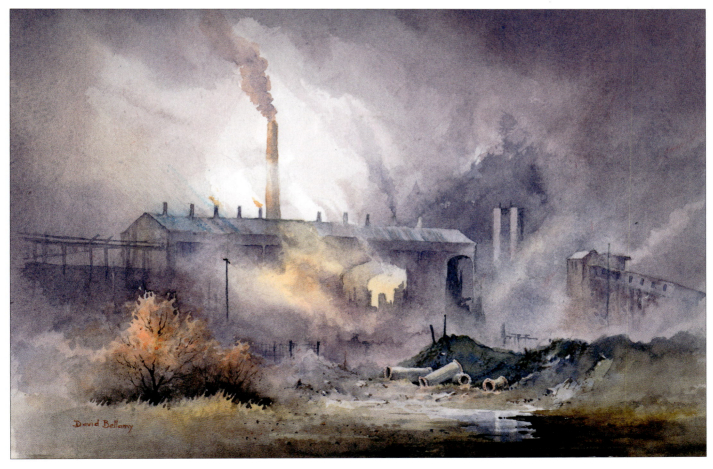

Isolated buildings

With isolated buildings in a country setting it is worth considering the mood you wish to convey. For example, in a wild mountain background, the impression of the inhabitants battling against a harsh landscape and climate can be accomplished by suggesting stormy weather and savage crags. Snow can have a similar effect. The isolation can be accentuated by surrounding the building with an empty landscape so that it looks rather forlorn.

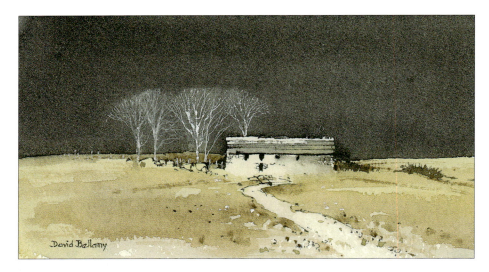

Old Barn
110 x 180mm (4³/₈ x 7in)

In this simple scene I use few colours, including white gouache for the trees, fence and a number of blobs in the foreground. Do not be afraid to use gouache if you feel it will work, as the opaqueness of the medium extends the possibilities with pure watercolour paints. Note how the bottom of the barn wall is not defined, making it appear as though the building is growing out of the ground.

Cottage Below Blencathra
160 x 240mm (6¼ x 9½in)

Where you need to push snow-clad mountains back into the distance, lay a wash of blue – in this case cobalt – over them. See how the closer whites push the ridge back. This is also useful when you have a white roof against a white background, so in this scene it has solved two problems. Patches of dark roof where the snow has melted are an alternative. It usually pays to add warm colour into a snow scene: the sky or water reflections can help in this matter and also warm-coloured vegetation. Without the clumps of yellow ochre grasses in the foreground it would feel extremely cold.

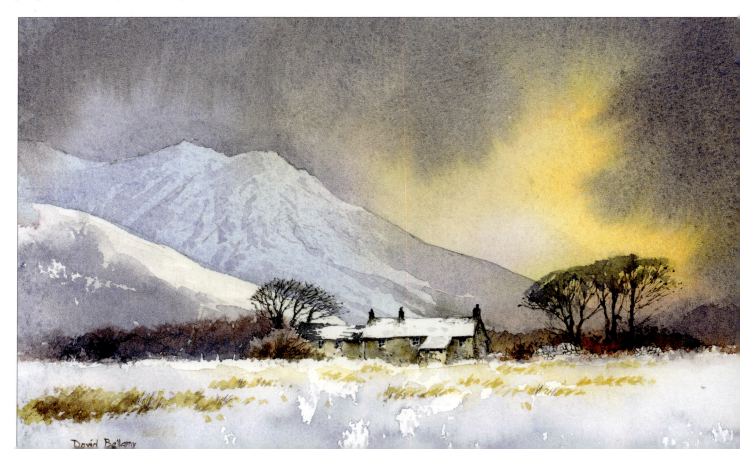

Painting in towns and cities

For those who enjoy painting buildings there is a wealth of material in most cities. Like my landscapes, I try to convey a sense of atmosphere in a town or city scene, and here this has to be accentuated even more because the depth in a city view is normally much less than in a landscape. As an example, where one building goes behind another I make the further building almost devoid of detail, even if I can see all the architectural details clearly. The need to include figures is essential, but they need not be large and can appear quite impressionistic. As far as it is realistic, move strong colours and interesting detail around to suit your composition, as towns are forever changing, and do not forget those rainy days when puddles can throw back exciting reflections and add sparkle to an otherwise dull scene. Dusk, when the lights come on and the atmosphere is often more dramatic, can be a good time to work.

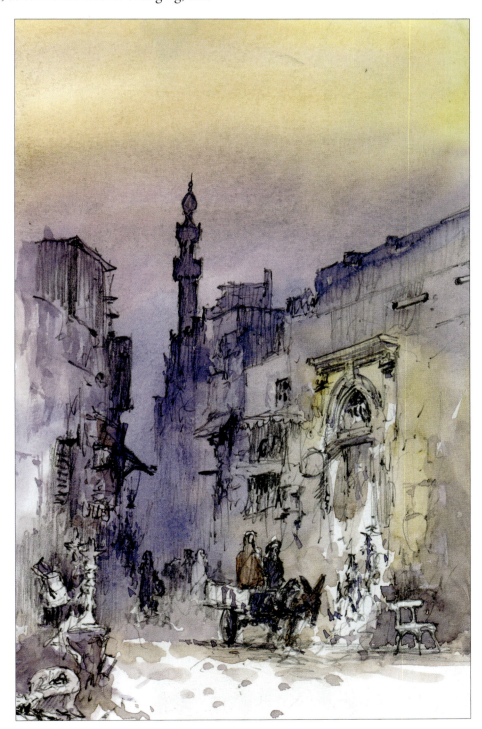

Cairo Street

This original watercolour sketch was carried out at twilight in the Islamic quarter of Cairo with bikes, donkeys and all manner of city life brushing past me. I aimed to lose unwanted detail in the atmosphere, and suggest a feeling of mystery. In a finished painting I would reduce the strength of the minaret to push it further into the background.

Old Farmhouse

Buildings always benefit from a little sunlight cast across them and here I intend to portray a sunny day in early summer in the countryside. The rustic old house has rather odd, quaint windows, which I have left in position, but you may wish to try a version with more conventional dormer windows.

YOU WILL NEED

640gsm (300lb) Not paper

Masking fluid and old brush

Colours: yellow ochre, cerulean blue, cadmium yellow pale, French ultramarine, raw sienna, light red, alizarin crimson, new gamboge, cadmium red, burnt umber

Brushes: squirrel mop, no. 7 round, no. 4 round, no. 00 round

Pencil and eraser

Scalpel

1 Draw the scene. Apply masking fluid with an old brush over the white front wall, the side wall and the chimney, and over the fence posts and pig wire on the left.

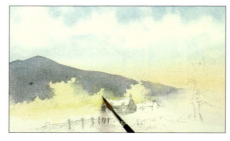

2 Use a squirrel mop to brush clean water over the painting to just below the horizon. Paint yellow ochre over the lower part of the sky.

3 Paint the top of the sky with cerulean blue, leaving some parts white for soft clouds. Bring the blue down into the yellow ochre.

4 Change to a no. 7 round brush and paint cadmium yellow pale over some of the trees. Allow to dry.

5 Paint the hills with a mix of French ultramarine, raw sienna and a little light red. Paint round the trees. Soften the edges on the shadow side of the masses of foliage with clean water. Allow to dry.

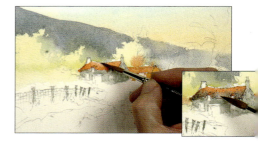

6 Paint light red across roofs and the right-hand side of the outbuilding. Lift out colour at the top of the main roof with a clean, damp brush. Pick up the hill wash and drop it into the bottom of the roof wash while still wet to 'dirty' it.

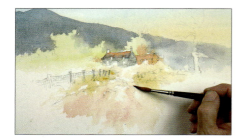

7 Mix raw sienna with alizarin crimson and lightly paint the driveway. Use the brush on its side to leave a ragged edge and patches of white paper.

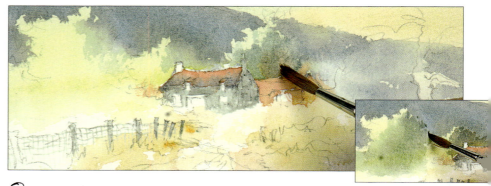

8 Paint the tree round the chimney with a mix of ultramarine and cadmium yellow pale, then drop in light red while wet. Paint the trees to the left of this one in the same way.

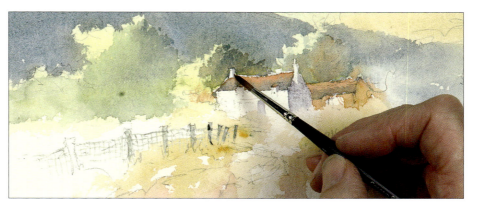

9 'Dirty' the roof of the outbuilding with a little ultramarine, raw sienna and light red. Change to the no. 4 round brush and use the dry brush technique and raw sienna to paint the trunk of the tree on the far right. Quickly drop in new gamboge while wet.

10 Remove the masking fluid from the building. Mix ultramarine and cadmium red and paint across the shadowed gable end of the building, the shadowed parts of the porch and the left-hand chimney.

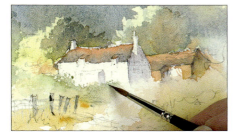

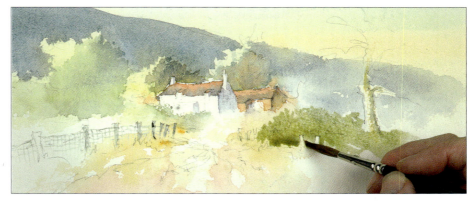

11 Shadow the outbuilding in the same way. Mix new gamboge and ultramarine and paint the vegetation in front of the cottage, softening it at the bottom with a damp brush.

12 Reviewing the painting at this stage, I decided to draw in two new fence posts to break up the hedge. Use the no. 7 brush and new gamboge and ultramarine to work round these posts with negative painting.

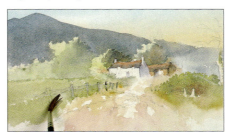

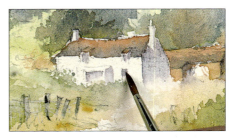

13 Drop in cadmium red while wet. Run yellow ochre into the bottom of the hedge area to avoid hard edges forming, then drop new gamboge into the hedge to liven up the colour.

14 Paint in the field on the left with new gamboge and ultramarine. Use a damp brush to soften it.

15 Use the no. 4 brush and ultramarine and cadmium red to paint the window shadows to make them look recessed.

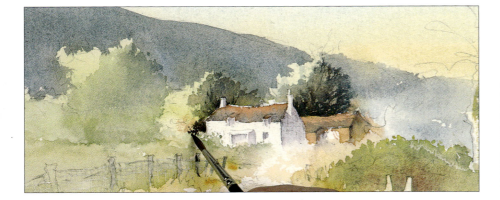

16 Use burnt umber mixed with ultramarine to paint the strong, dark tree behind the buildings, that describes their shape. Make the outbuilding roof irregular to give it character. Use the side of the brush to paint the darker parts of the foliage. Repeat for the trees to the left of the buildings. Add a little light red to the mix to warm it up.

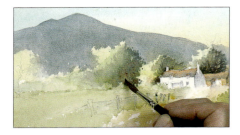

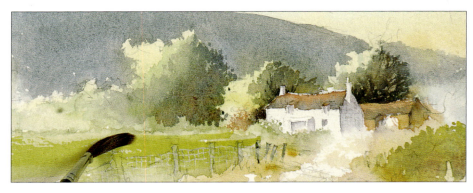

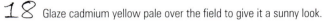

17 Use the no. 7 brush and the hill mix of ultramarine, raw sienna and a touch of light red to paint the shaded parts of the trees on the left. Drop in cadmium red while wet to warm up the shadow.

18 Glaze cadmium yellow pale over the field to give it a sunny look.

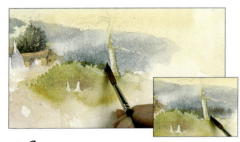

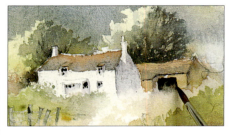

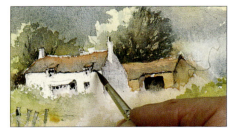

19 To make the trunk of the right-hand tree stand out, re-wet the upper part of the hill behind it and drop in the ultramarine, raw sienna and light red mix. Drop in ultramarine and burnt umber wet into wet at the bottom.

20 Change to the no. 4 brush and use the ultramarine and burnt umber mix to paint in window details and the doorway of the outbuilding. Soften the bottom of this dark block with clean water to suggest sunlight coming in.

21 Use the same brush and mix to paint a line under the eaves and other architectural details on the cottage and the outbuilding.

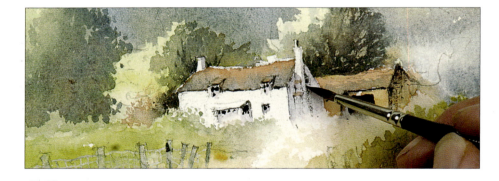

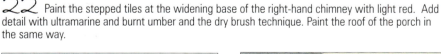

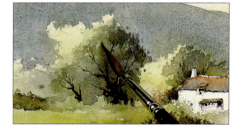

22 Paint the stepped tiles at the widening base of the right-hand chimney with light red. Add detail with ultramarine and burnt umber and the dry brush technique. Paint the roof of the porch in the same way.

23 Paint the vegetation behind the fence posts with light red mixed with a touch of ultramarine and the dry brush technique. Drop in light red while wet.

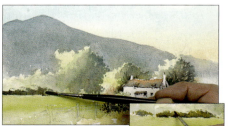

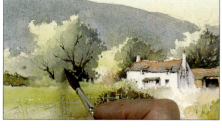

24 Paint dark foliage at the far edge of the field with the side of the brush and burnt umber mixed with French ultramarine. Drop in yellow ochre to the upper part while wet.

25 Dip the no. 7 brush in ultramarine and burnt umber and get the brush to a very fine point. Paint the trunks and branches of the main trees to the left of the buildings.

26 Paint in the darker foliage that the branches disappear into with the same mix.

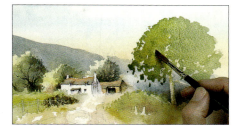

27 Mix new gamboge and ultramarine for a strong green and paint the foliage of the tree on the right. Drop in more new gamboge on the left while wet to suggest the sunny side. Allow to dry.

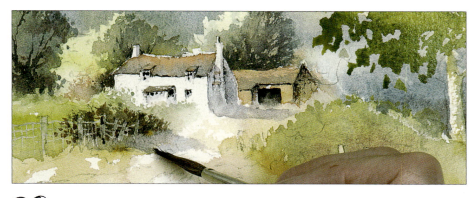

28 Mix ultramarine and cadmium red for shadow. Go back over the gable end of the cottage and paint a cast shadow. Soften the edges a little with a damp brush. Paint a cast shadow from the hedgerow in the same way.

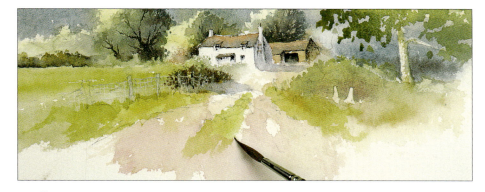

29 Paint cadmium yellow pale over the grassy areas beside and along the middle of the pathway.

30 Make a dark mix of burnt umber and ultramarine to paint the bottom of the foliage behind the fence on the right. Paint the upper part of the foliage with watered down burnt umber and drop in a touch of cadmium red.

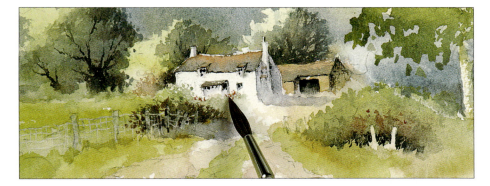

31 Using the point of the brush, dab some cadmium red for flowers against the white of the cottage, for a striking effect.

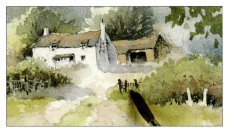

32 Use ultramarine and burnt umber to paint dark posts against the light of the yard. Then paint the grass beneath the posts with a mix of ultramarine and new gamboge.

33 Use the shadow mix of ultramarine and cadmium red and paint shadows across the field from trees off the left-hand side of the picture. Add more shadow where required to the buildings and to the tree trunk on the far right.

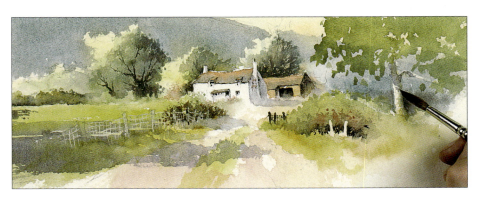

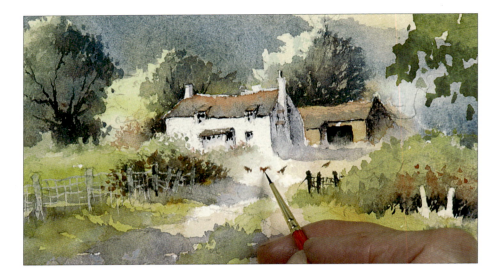

34 At this point I stepped back from the painting and decided to add some chickens in the yard. Draw them in first then use the point of the no. 7 brush and light red with a touch of burnt umber to paint them. Change to the 00 brush and give the chickens one leg each. Add a touch of cadmium red for the combs. Paint cast shadows with ultramarine and cadmium red.

35 Define the edges of the grass in the middle of the path with the same shadow mix. Add darker tones to the right-hand tree with ultramarine and burnt umber and the no. 7 brush. Soften the edges with clean water.

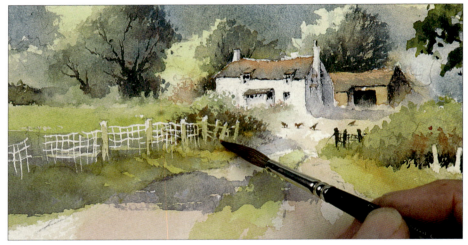

36 Rub the masking fluid off the fence. Paint over the fence with raw sienna, leaving white at the top of the fence posts.

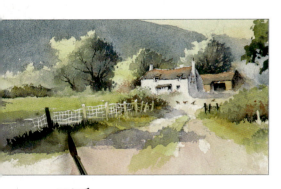

37 Make one of the posts dark in front of the light field with a mix of burnt umber and ultramarine. Add some of this tone to the top of the grass verge. Soften it in with clean water.

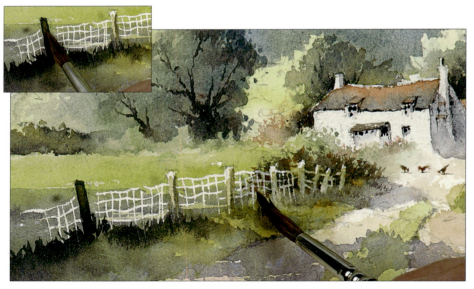

38 Paint yellow ochre on to the shadowed sides of the light posts, and on to the dark post. Subdue the white of the pig wire with a weak wash of ultramarine.

39 Use a scalpel blade to scratch out a length of wire between the fence posts on the right. Use an eraser to rub out any distracting pencil marks.

The finished painting.

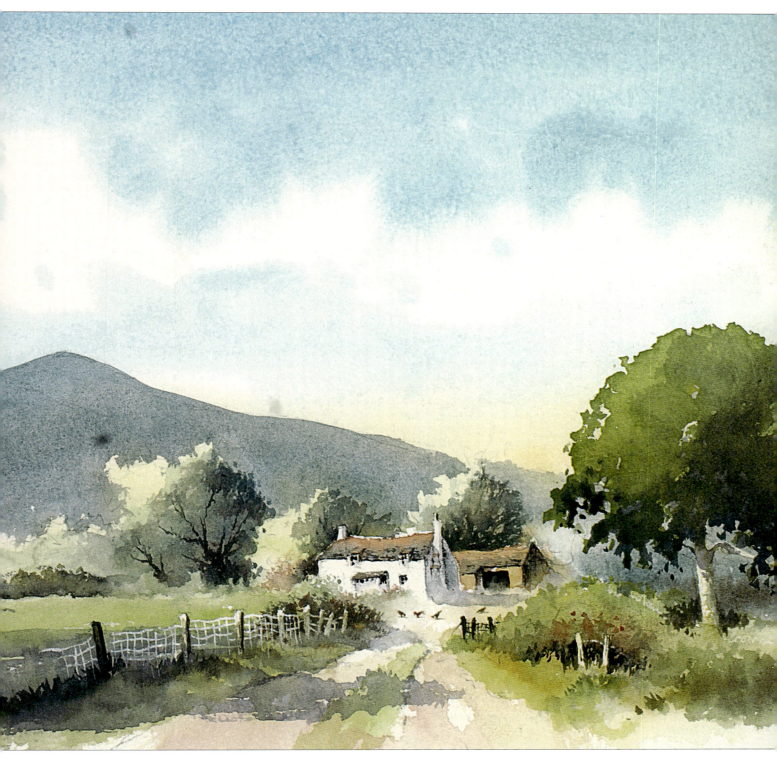

Painting people

The thought of painting figures makes many artists nervous, whether rendering a full figure as the main subject of a painting, or simply including one as a small feature in a landscape or city scene. In this chapter we shall look at figures as subjects in their own right, including a brief look at portraiture.

The nude figure

As with still life, life drawing is not just about creating a finished picture, but is an unrivalled method of learning to draw. We can immediately see where we are going wrong, the importance of the correct proportions and how the image is drastically affected by only slight alterations in the pose. If you critically observe the figure, comparing the various elements and how they affect each other your work will progress rapidly. Even if you are not interested in painting figures, working from the nude model is by far the best way of developing drawing and observation skills.

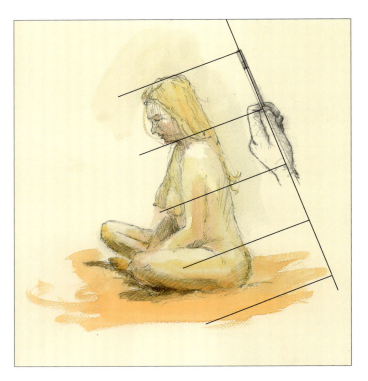

Emma I

Taken as a rule of thumb, the head is an extremely useful tool to use as a measuring device as you are drawing. As the body moves, it assumes different shapes and the various parts also change in length according to the pose: if the model had risen her head the distance from the bottom of her chin to the bottom of her breast would be markedly different. Use your pencil held at arm's length to compare sizes with the head, moving the thumb along the pencil as a marker.

Basic anatomical shapes

It pays to begin by working on the more basic and simpler shapes. One of the problems with drawing the clothed figure is that generally only the more difficult parts of the body – hands, feet and head – are visible. Initially draw a basic outline in light pencil so that it is easily worked over, and observe carefully where the critical points appear and relate to other parts of the body, for example note where the point of the elbow comes when compared with, say, the hip bone. You may need to make minor adjustments as you progress. Note how the body changes its shape in places when adopting a new pose. Is the head the right size in relation to the other features?

Critical points and tensions

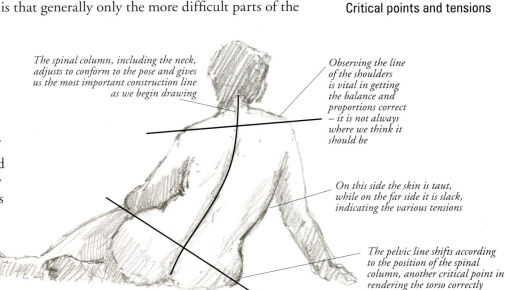

The spinal column, including the neck, adjusts to conform to the pose and gives us the most important construction line as we begin drawing

Observing the line of the shoulders is vital in getting the balance and proportions correct – it is not always where we think it should be

On this side the skin is taut, while on the far side it is slack, indicating the various tensions

The pelvic line shifts according to the position of the spinal column, another critical point in rendering the torso correctly

Disregard facial features for the time being and concentrate on the basic shape of head and hair. Note how when a part of the body is moved it will affect other parts. Try doing some gestural sketches in charcoal, conte, pencil or watercolour, without feeling the need to finish a complete figure. Such sketches are invaluable in learning the various attitudes of a figure and getting all the features in the right proportions.

Getting the balance and movement right can be tricky, and the figure can look stilted if this is not quite right. Draw an imaginary plumb line down from the head. Where this line meets the ground check that this occurs at one foot or between both feet, as this will suggest firm balance. If the point is outside these limits there needs to be a reason why the figure is not properly balanced: perhaps pushing something, leaning against a wall or involved in some other activity that justifies this imbalance.

Here the figure is relying on the wall to maintain balance

This figure is well balanced: the head is direcely above the firmly placed foot

Here the figure is thrusting forwards and slightly off-balance

Balance – using a plumb line from the head

Even slight changes in a pose can affect the balance, so it is important to be aware of these points, otherwise the figure will look wrong.

Dorothy
290 x 200mm (11½ x 7⅞in)

This is more of a gestural study on cartridge paper to explore shapes; a good exercise before carrying out a finished painting. This approach, where so much is left unfinished, can have a charm of its own and is a useful method when you only have a limited amount of time, or wish to concentrate almost exclusively on a particular part of the figure. Gestural studies are excellent as a warming up exercise and for getting the main proportions correct. They enable you to outline the size and shape of head, hands and feet without actually drawing in all the facial features, fingers and toes.

Hands and feet

When it comes to drawing feet and hands simply block these in in outline rather than define each finger or toe. This will help you suggest the hands and feet without detail, and allow you to check they are in scale – compare them with the size of the head. It is a sobering thought that in some paintings even some of the old masters did not quite get their hands and feet in the right proportions with the rest of the figure, despite being beautifully executed. When you feel more confident, try drawing the fingers and toes, but it is still important to block the overall shape of hand or foot in first. Because these features are more liable to mistakes it can put many off figure drawing, but keep practising from the figure and you will see a great improvement.

The outline of a hand blocked in with construction lines

The finished hand

Practise drawing your own hand in a variety of poses

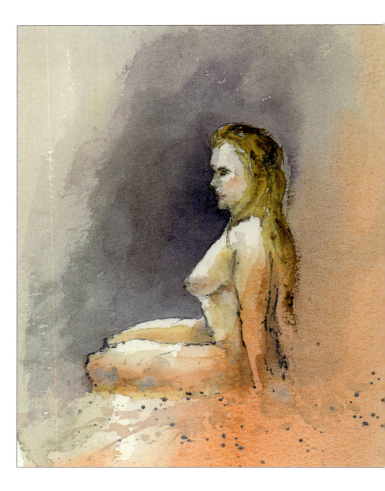

Blocking in a foot with the aid of lightly drawn construction lines

The completed foot

Emma III
250 x 180mm (9⅞ x 7⅛in)

Because time is short I use rapid brush-strokes to capture the pose, then draw into the wet washes with a mid-grey watercolour pencil. With a watercolour pencil you do not have to wait for the wash to dry – just draw straight into it. Naples yellow is laid across her torso, face and thighs, then some yellow ochre dabbed in, in each case avoiding the areas where highlights are to remain as white paper. I drop a little vermilion into her cheek, letting it run into the still-damp colours there. I wait until the other colours are properly dry then re-wet her lower thigh and breast. Into part of her lower thigh vermilion is painted with a mop brush, flicking it up over her arm and back and bringing it down into the foreground. Then I dab a touch of cerulean blue into her thigh. With a small round brush, I place vermilion across the centre of her breast into the wet paper, and as this softens out, introduce a hint of cerulean blue. This leaves the underside of her breast light to hint at reflected light and suggests a lovely roundness. When this is dry I define the underside of the breast with some vermilion and a touch of cerulean on her side below the breast. Her hair is rendered with yellow ochre, dropping in burnt umber while still wet. Finally, when the paper is completely dry the dark background is painted with a mixture of French ultramarine and cadmium red.

The clothed figure

When you have studied the structure of the human body you will be better equipped to render the clothed figure. Note the way garments hang or cling to the figure, where the tensions appear, and how this affects the way we see the fabric, especially the highlights. I often carry a sketchbook around town with me, as so many opportunities can arise in cafes, public transport, theatre, sports events, and so on. As the person may leave at any moment there is a great incentive to quickly capture the salient aspects of the posture. It helps to draw an outline structure of the figure before spending time on the clothing.

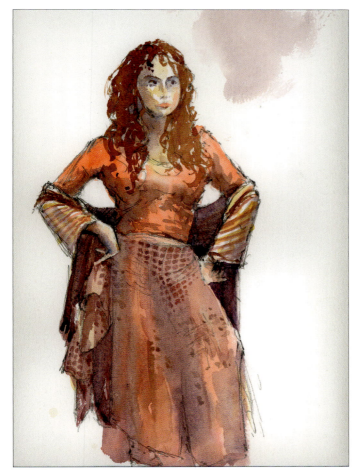

Katherine

300 x 190mm (11¾ x 7½in)

Katherine struck a marvellous pose, but this proved quite a challenge with all the intricate folds of her garments. The net effect went right across her skirt, but to include every nuance of detail would have been an enormous task so I suggested just a few, painting negatively and losing the edges. Once the skirt was dry, I washed over it with a transparent glaze of weak permanent alizarin crimson. Her hair presented me with a major problem as it cascades so beautifully down, tempting me to paint every delightful curl, but here I have tried to capture the overall effect without over-working.

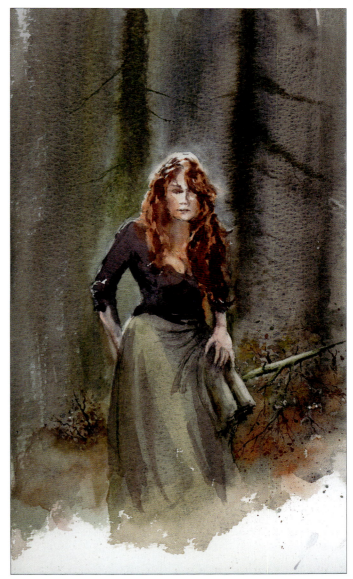

Katherine in the Trees

240 x 170mm (9½ x 6¾in)

With backlighting and a dark background this accentuates a sense of mood. The trees are painted wet into wet, and the difficulty is to keep the soft-edged halo of light falling on her head. In this pose I concentrate more on the head, putting more shape into her flowing red hair and playing down her body by comparison.

Capturing people in action

Rather than having figures standing around looking phased out, try to inject some action or dynamism into them. Seek out situations where they are doing some activity, whether they are just a small part of the scene, or the main focus. Caving is one of my interests and sketching cavers in difficult or life-threatening situations lends an edge to the work that is difficult to obtain in most situations – for both the subject and the artist at times. The tension and dynamism in the body hanging on for dear life above an abyss can come across in the sketch, so if this dramatic approach appeals to you seek out sports and activities that offer these opportunities. It is also useful to build up a collection of drawings and photographs of figures taking part in all manner of actions.

Angela in SRT Kit

I did many sketches of competitors at the rope-climbing competition at a caving conference. Angela did not pose for me, she simply got on with the job of scaling a rope, so I was forced to work extremely fast as she shot up the rope. While prone to many mistakes, this approach encourages a strong sense of dynamism and energy in a work, even when the subject is standing still.

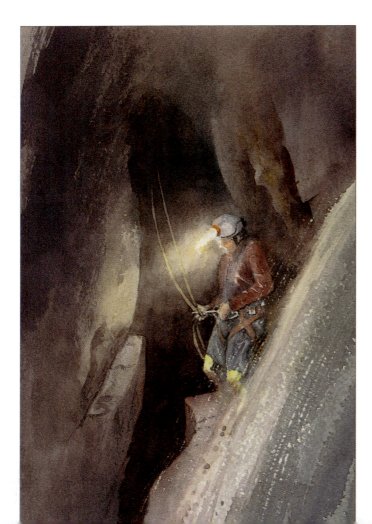

Robin Grey in Swinsto Hole

220 x 160mm (8⅝ x 6¼in)

Here Robin is detaching himself from the rope, after abseiling down one of many pitches in Swinsto Hole. The bent knees and hunched shoulders indicate the awkwardness of having to concentrate in the light of a head-torch with water crashing down within inches, and the pressure that a single mistake would almost certainly be fatal. The attitude and stance of the person can be critical in achieving a sense of realism.

Sketching people abroad

When I go abroad, especially to Third World countries, I like to sketch people as often as I can, whether road workers, sheikhs or people running around with spears and clad solely in loincloths as we did on a Zulu war battlefield. Sometimes when they see me sketching the landscape they ask me to do a portrait of them, which I usually do – if they look interesting I do two, keeping one for myself. It is always best to ask, and remember these people are often so poor that it is only fair to pay them for their co-operation. One wrinkle-faced woman in Ladakh hated the portrait I had done of her so much she demanded double payment.

Desert Guides Around the Campfire

This sketch was done on cartridge paper using a water soluble pencil. With the smoke swirling and figures moving about, there was constant change, with some appearing in strong detail and others merely as shadowy silhouettes. As with most Bedouins, sheesha and teapot are prominent. In a scene like this, one or two figures need to be more prominent, perhaps appearing more animated than the others, rather than having them all sitting around.

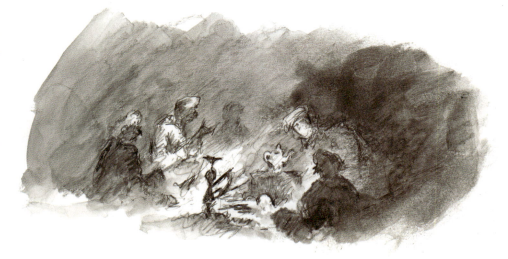

Sheeshas and Shadows, Tunis

160 x 230mm (6¼ x 9in)

The shapes and patterns intrigued me and I needed to render them without over-doing the effect. Still life studies of sheeshas, tile patterns, exotic lamps and so on help to give a painting like this an air of authenticity, to provide a setting for the characters. Light streaming through a window is always a fascinating intrusion and a superb device for highlighting patterns, while losing them in the shadows.

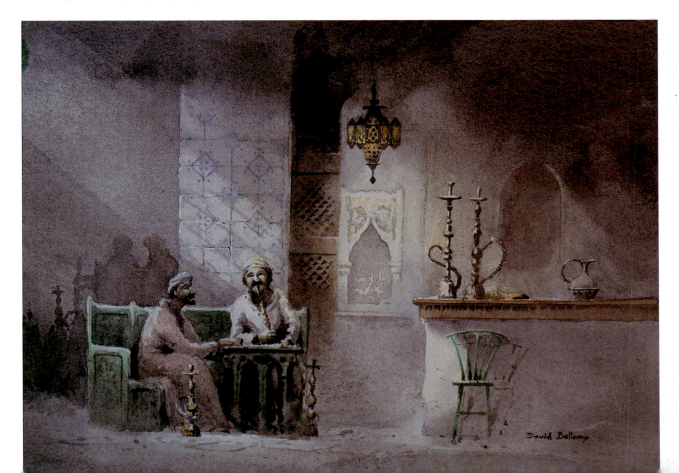

Portraits

Portraits are among the most challenging of subjects, and watercolour is not the most sympathetic medium to achieve good results. It pays to let the medium have its way in places by allowing colours to run into one another and losing edges here and there. Try to avoid taking each feature in isolation – for instance, use shadow or colour to join the eye to the nose rather than have the eye standing out starkly in grand isolation. Strong stabs of dark tones on their own really can spoil a portrait, and in places edges such as the hairline benefit from being softened to blend into the skin. Look for subtle changes of colour that can add interest to a face.

Getting a likeness can be fraught with difficulty. Some people are much easier than others, especially when they have distinctive facial features. It is worth beginning by doing a few quick sketches from various angles, applying tone at the same time. Charcoal or conte crayon is ideal for this. Which of the views is most conducive to obtaining a likeness? Which one are you most comfortable with? Going through this process will help you avoid the most challenging aspects and will hopefully set you on the right track for a successful portrait. Getting the facial proportions right is vital in order to obtain a likeness.

Sonam
260 x 200mm (10¼ x 7⁷/₈in)

I met Sonam at the Hemis festival in Ladakh, a lovely old man with a fascinating weather-beaten face, a common feature of so many people living a truly tough existence in this mountain desert region of the Himalayas. Lined and wrinkled faces usually make it easier to obtain a likeness, but try not to make the lines too dark. The highlights on his face are achieved by leaving the paper white, and the colours I use for his tanned face are raw sienna, burnt umber and in places a touch of vermilion.

Grace in Pensive Mood
210 x 150mm (8¼ x 5⁷/₈in)

For the skin tones I use burnt umber, French ultramarine plus raw sienna in places, with wet, fluid washes to retain the softness of Grace's features. As I want to lose the right-hand side of her head into the background, I paint her hair last and brush the really dark background outwards in the same wash. This portrait was carried out in very low lighting.

Facial features and the self-portrait

Naturally the most convenient person whose portrait you can paint is yourself. All you need in addition to your painting materials is a mirror or set of mirrors – the latter will provide you with a greater variety of angles of course. It pays to think about what sort of mood you wish to put across, before you start painting: do you wish to appear sombre, humorous, stern, or what? Arrange the lighting to enhance that mood and to highlight any features you wish to accentuate.

Two pairs of lips

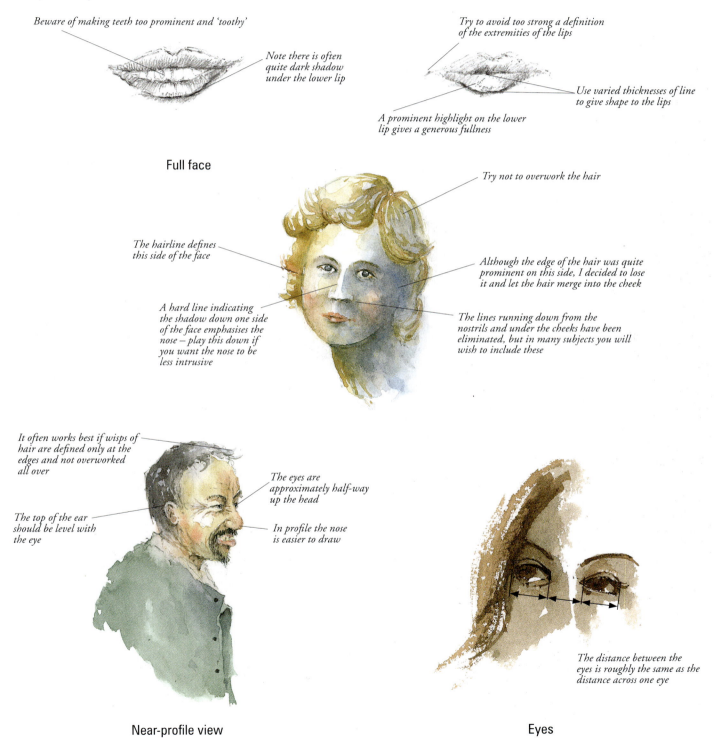

Beware of making teeth too prominent and 'toothy'

Note there is often quite dark shadow under the lower lip

Try to avoid too strong a definition of the extremities of the lips

Use varied thicknesses of line to give shape to the lips

A prominent highlight on the lower lip gives a generous fullness

Full face

Try not to overwork the hair

The hairline defines this side of the face

Although the edge of the hair was quite prominent on this side, I decided to lose it and let the hair merge into the cheek

A hard line indicating the shadow down one side of the face emphasises the nose – play this down if you want the nose to be less intrusive

The lines running down from the nostrils and under the cheeks have been eliminated, but in many subjects you will wish to include these

It often works best if wisps of hair are defined only at the edges and not overworked all over

The eyes are approximately half-way up the head

The top of the ear should be level with the eye

In profile the nose is easier to draw

The distance between the eyes is roughly the same as the distance across one eye

Near-profile view

Eyes

Painting groups of figures

Groups of people make fascinating subject material. Sports events, town scenes, cafes, beaches – the list is endless where you can find opportunities. By lowering the light and maybe rendering some figures simply in silhouette the group becomes more conspiratorial and dramatic, so again it is worth considering the mood. Which figure will be the focal point? In any group you will need one or perhaps two figures to stand out in this role, with the others acting as a supporting cast. Make sure their stances vary, and have some gesticulating, writing, or doing something different to avoid monotony. Allow figures to run into one another so that they become a mass rather than a series of individuals each separately rendered.

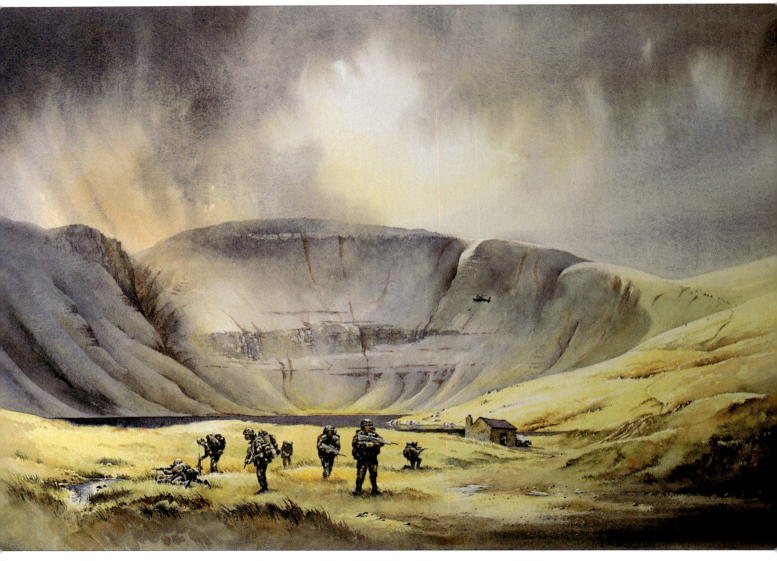

Cambrian Patrol
610 x 890mm (24 x 35in)

I painted this scene for the army during their annual exercise in the Welsh mountains in extremely wet and wild conditions. Each soldier had to be sketched separately, and having to capture the poses when they had no idea what I was up to proved hilarious at times. Many patrols were from overseas, including Dutch, Indian, Foreign Legion and so on, but in the end I decided on a British patrol for the final painting. More than anything I wanted to capture both the sheer exhaustion of carrying heavy kit and weapon packs across rain-sodden peaks, and a sense of camaraderie. Thus it needed a number of studio sketches to get the right attitudes as well as a composition that fitted both the artistic needs and the operational requirements of moving through (apparent) hostile territory.

Capturing a mood

Once you gain experience in painting figures, think about how you wish to portray their mood – will they be lively, morose, happy, aggressive or relaxed? Spend time observing how people hold themselves and how their stance gives a clue to their mood. If you work from models, ask them to adopt poses that suggest different moods and emphasise this in your work.

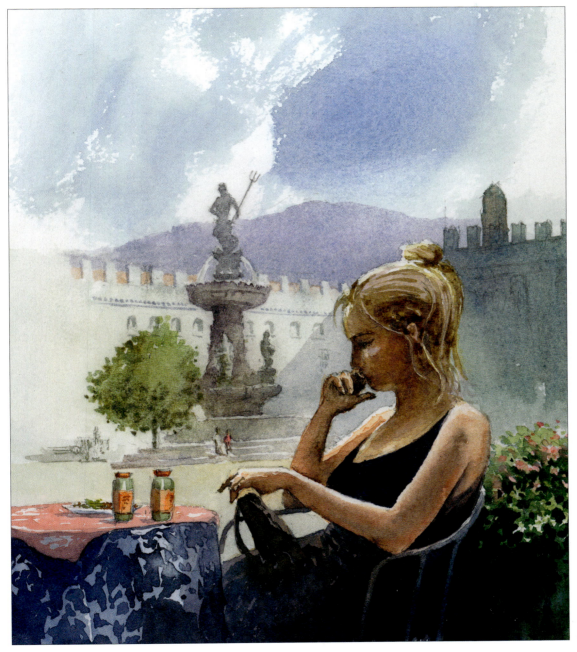

Catherine in Piazza del Duomo, Trento
210 x 170mm (8¼ x 6¾in)

I wanted to retain the complex statue of Neptune in the background, even though he seemed a bit out of place in the mountains, and so played down the detail considerably so that it would not dominate the composition. Catherine was deep in thought, and I tried to put this across rather than simply paint a portrait. The strands of her hair were painted negatively, and this is something that can only be acquired with experience, but with practice it can be achieved.

Women at a Peruvian Market

The ladies of the High Andes make lovely subjects with their sombreros and colourful clothing, and in this demonstration I am including one who was actually at the market and another I met in a nearby village. When using a variety of sources, it helps to do a studio sketch before tackling the painting, to ensure that the composition works, and in this case that the two figures relate to each other. After you have read through many of the stages you will realise that I constantly use washes of cadmium red and French ultramarine. With this in mind I mix up enough colour to keep me going throughout the painting, not just for the first wash.

YOU WILL NEED

Not paper, 120 x 170mm
(4¾ x 6¾in)

Colours: Naples yellow, raw umber, new gamboge, cadmium red, French ultramarine, yellow ochre, burnt umber, cobalt blue, viridian, perylene maroon

Brushes: no. 4 round, no. 7 round, squirrel mop, no. 1 rigger

Pencil

1 Draw the outline in pencil on a Not watercolour surface.

2 Apply Naples yellow to the sombreros with a no. 4 round brush.

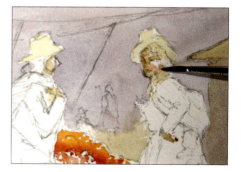

3 Mix a weak wash of raw umber and lay this over the building and ground.

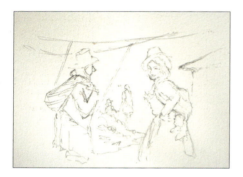

4 Paint part of the produce with new gamboge using a no. 7 round brush. Immediately drop in some cadmium red at the bottom, and allow it to seep upwards to give variation to the colour.

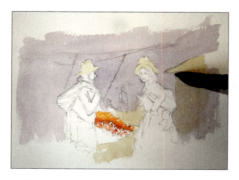

5 When the paper is dry, use a squirrel mop to brush a weak mixture of French ultramarine and cadmium red over the background, taking it over the building.

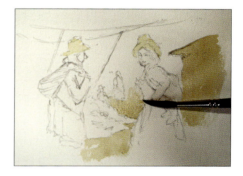

6 Use a no. 4 round brush to wash a weak mixture of yellow ochre and burnt umber across the faces, leaving a small highlight of bare paper. Straight away drop a hint of cadmium red into the cheeks to warm them up.

7 For the drab-coloured sack, take the French ultramarine and cadmium red mixture and add a touch of new gamboge. Lay this on with a no. 7 round.

8 Paint the blanket stripes with cobalt blue.

9 Paint the cardigan on the left-hand lady with cadmium red.

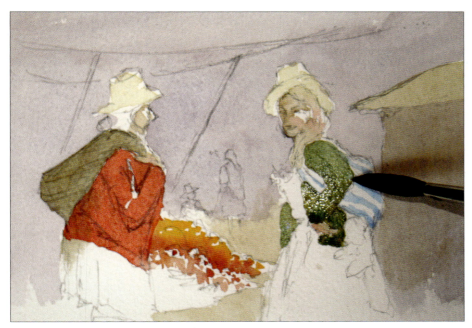

11 Use French ultramarine and cadmium red for the shadowed sides of the faces.

10 Mix cobalt blue and yellow ochre for a dull green to paint over the right-hand figure's cardigan, lightening it on the upper arm by lifting out with a damp brush.

12 Use French ultramarine on the right-hand skirt to suggest shadows and creases. This is done using dry brush strokes down the paper.

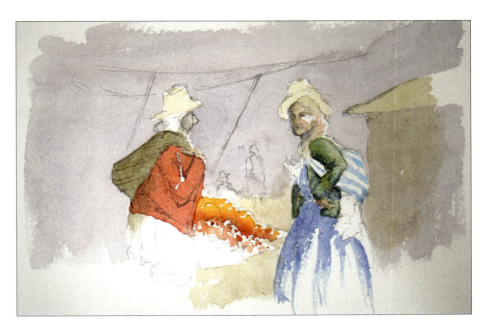

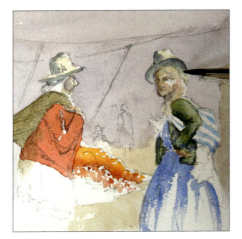

13 Mix a little French ultramarine and raw umber to paint the shadowed side of the sombreros.

14 With a no. 1 rigger, describe the detail on the faces with a combination of French ultramarine and burnt umber, and touch some weak cadmium red on the lips.

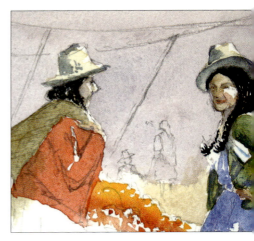

15 With a much stronger version of the French ultramarine and burnt umber mix, paint in the hair on both figures using a no. 4 round brush.

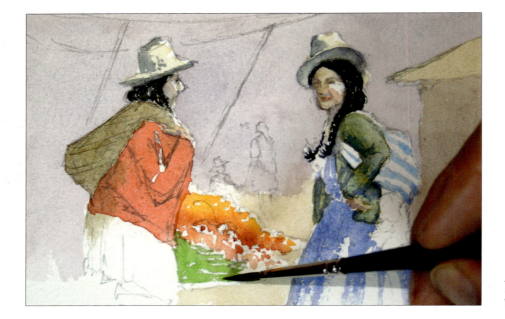

16 For the green vegetables, mix viridian and new gamboge.

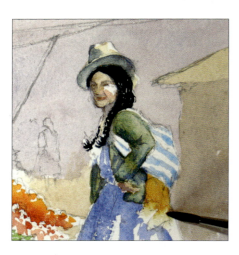

17 Paint the baby's legs with yellow ochre.

18 For the pattern across the blanket, paint perylene maroon in discontinuous lines parallel with the cobalt blue bands.

19 Because of the strong top hairline, soften the edge to create a less harsh image and slightly darken the tones of the face with a no. 4 brush and some burnt umber and French ultramarine.

20 Paint a wash of cobalt blue across the left-hand skirt using a no. 7 round brush.

21 Render the background figures with the French ultramarine and cadmium red mixture, ensuring that they are quite a bit stronger in tone than the background. Making them silhouettes helps push them into the background.

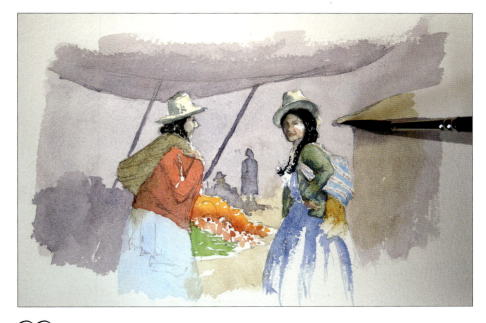

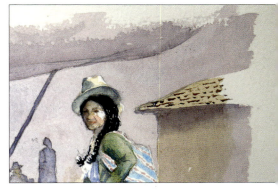

23 The texture on the roof is achieved with burnt umber in small dabs.

22 Apply the same mixture to the awning, poles and the shadow of the eaves.

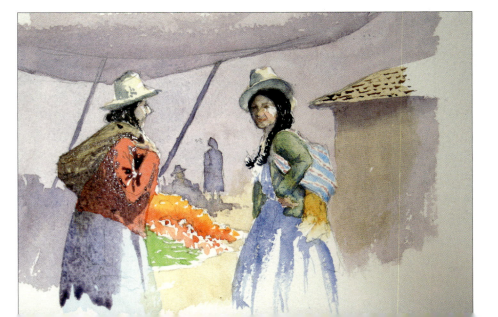

24 More of the French ultramarine and cadmium red mix is used to define the shadows on the left-hand figure's sack and clothing.

25 Use the same ultramarine and cadmium red mix to paint the shadow areas of the right-hand figure and the baby's leg.

26 Apply the same mix to paint the shadows cast across the fruit.

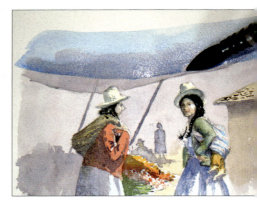

27 Adjust the tone on the awning with the squirrel mop and cobalt blue.

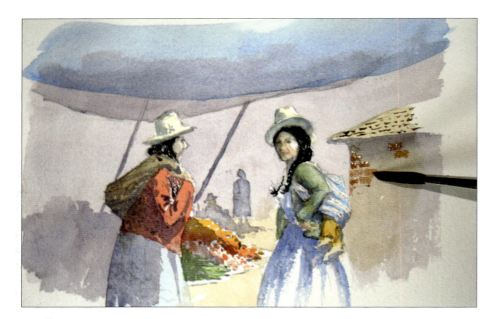

28 Describe a few of the bricks in the wall using a combination of cadmium red and yellow ochre with a no. 7 round brush. Resist the temptation to paint in every brick.

29 To soften the background figures, brush clean water across them with a no. 7 brush, just enough to lose their hard edges. If this leaves a pool of water on the surface, mop up with a paper tissue. Strengthen the shadow on the left-hand sombrero with some French ultramarine and cadmium red.

30 With French ultramarine and burnt umber, describe the baby's head and strengthen shadows on the legs with a no. 4 round brush.

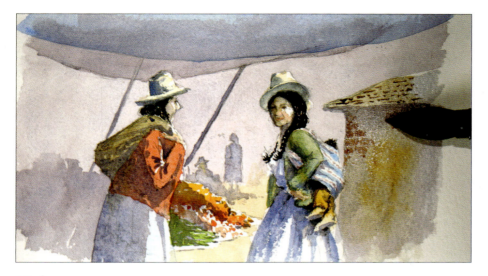

31 Apply a glaze over the building using French ultramarine and cadmium red, again using the mop. Quickly drop in some yellow ochre for variation. The glaze softens the brickwork and makes it look more mellowed.

32 Finally use the no. 4 round brush with burnt umber and French ultramarine to define detail around the right-hand figure's hand.

The finished painting.

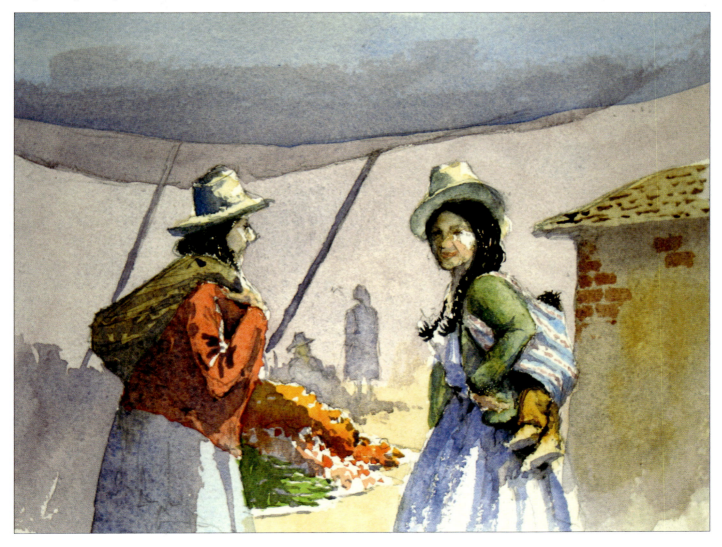

Coastal scenery

Painting coastal scenery can be one of the most enjoyable occupations or pastimes, depending on how you view the subject. Waves, moving water and the intricacies of boats can be challenging, but if tackled the right way, these difficulties can be overcome. Whether you sketch or paint on the shoreline, out at sea, or even in the sea as I sometimes do, there is never a lack of suitable subjects.

Beaches and surf

The line between beach and surf can vary considerably – hard-edged in places, soft in others, or even completely lost. Use these variations to your advantage, and perhaps break the line up with rocks, figures or boats. A wet beach is highly reflective, and you can position your reflections where they offer maximum benefit, perhaps supporting a focal point. Expand or contract the wet area to suit your purpose, or break it up into bands and create intermittent reflections. Large areas of beach can be punctuated with rocks, pockets of pebbles, strands of seaweed, rivulets of streams running into the sea or pools of deeper water.

If you stand well away from the water's edge, the surf and waves are more distant, and therefore easier to render until you feel more confident. You can simply suggest them with a few broken and horizontally elongated strokes of a medium round brush, leaving much of the paper untouched to represent the foaming surf. If you make the sea beyond this band a few degrees darker, this will give the surf more impact.

Misty Day, Freshwater East
150 x 220mm (5⁷/₈ x 8⁵/₈ in)
The soft background greys contrast strongly with the hard edges of rocks and waterline. Standing back a little from the waterline makes it easier to render waves and surf, and the movement of the sea seems less daunting. At this range you can keep things simpler. Once you are more confident, move in closer.

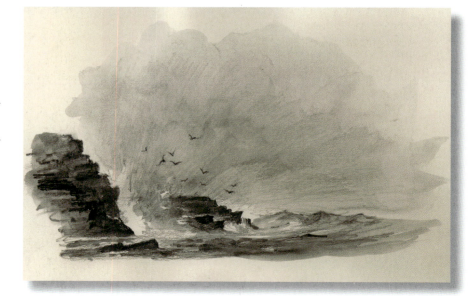

Lively Sea, Druidston

Water-soluble graphite pencils are an excellent medium with which to capture the nuances of water crashing on to rocks. I normally use a no. 4 or 6 round brush to wash over the tone after applying it to dry paper. There is a sense of energy in this sketch that is difficult to recapture in the studio, which is why working out of doors teaches you so much.

Waves and lively seas

The repeated action of the incoming sea can be mesmeric, but try to observe these actions in a structured way. Forget about the pencil or brush for a while and simply study the way a wave hits the rocks. This will change according to the size of the wave and the varying state of the tide. Study how waves wash over half-submerged rocks, the way the undertow drags water back into the sea. With waves themselves, get in close and observe how they rise, start to curl over and eventually break and become a mass of foaming white surf. Note carefully all these stages, one at a time, and then capture them on paper. Photograph these stages for the detail, but vigorous handling of your pencil or brush will give you an energy and dynamism that no photograph can match. Take care, though, where you venture and remember that seawater can wreck a camera. Most of all watch the tide: not only does it change an aspect of your composition, but it can cut you off.

As the wave approaches the shore, its crest tends to vary according to where it begins to break

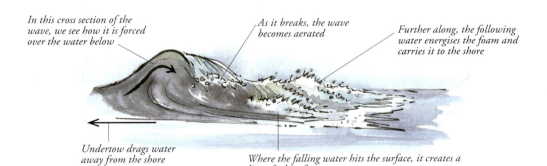

In this cross section of the wave, we see how it is forced over the water below

As it breaks, the wave becomes aerated

Further along, the following water energises the foam and carries it to the shore

Undertow drags water away from the shore

Where the falling water hits the surface, it creates a line of white foam

The breaking wave

Studying waves at close quarters is excellent practice. Observe them for a while before doing any drawing, and in particular note how all the elements shown in this diagram relate to each other.

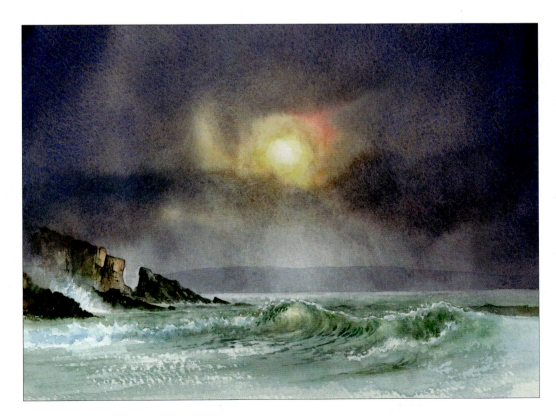

Waves at Nolton Haven
210 x 270mm (8¼ x 10⅝in)

*The sea was painted mainly with Winsor blue with a little burnt umber added, and also raw sienna in places.
In the lightest area of the wave, cadmium yellow pale makes it stand out, particularly with the darker blue-green blobs providing tonal contrast.
Of vital importance is the need to keep the crest of the wave light against the darker background, at least as the wave breaks – elsewhere this can be reversed of course. This has been accomplished by leaving the paper white, although a scalpel has been useful to scratch out minor highlights. Note how the crest of the wave undulates.*

The interaction of rocks and sea

When rocks meet the sea, there is generally a lot of white water foaming around. You have a choice of using masking fluid, wax resist, white gouache or negative painting. Scratching out with a scalpel is also an extremely effective method, but best left until the final stages of the painting. It can also come to the rescue when all other techniques fail. I only use white gouache for very small areas like spots or wiggles of foam or the thin crest of a wave. Experiment with all these techniques. To get a sense of energy and power in a crashing wave, work with rapid, energetic brush strokes, including when you apply masking fluid. Working on a Rough surface will accentuate any ragged edges you wish to incorporate into the churning water.

A fascinating feature on a lively shoreline is when the wave has crashed on to a shapely rock and you see the moment when the water is draining back into the sea. Seek out handsome rocks where you see this effect, and after watching it for a few minutes, try to capture the manner in which it drains off. Every so often you will find a larger than normal wave will arrive, and this is even more exciting. Go for the most prominent aspects of the feature and not try to capture every nuance of rock and spill. Avoid making all your marks hard-edged.

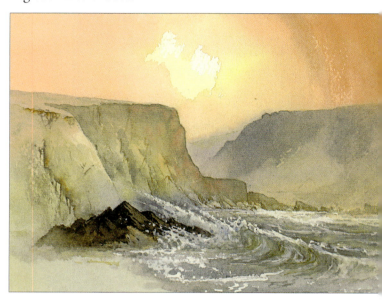

Coast at Hartland Quay
160 x 210mm (6¼ x 8¼in)
In the painting of Freshwater East (page 114), the large splash of white water was deliberately kept soft, but to create a more energetic splash of water hitting rocks, try using masking fluid as in this watercolour. Take a no. 4 or 6 brush and brush masking fluid vigorously in the direction needed – Rough paper is excellent for this as the technique is similar to dragging a dry brush across the paper. Experiment on scraps of Rough watercolour paper first.

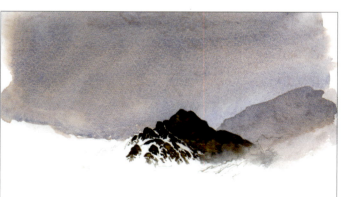

1 Lay the sky with French ultramarine and a touch of cadmium red. When it is dry, the background rib of rock is painted with a darker tone of the same mixture.

2 Further splashes of the mixture are dropped in over the lower part of the rock and then the rock itself is painted with French ultramarine and burnt umber, working in the smaller eminences of rock but leaving white where the water runs off. While this is still wet I drop in some raw sienna to suggest a variation in colour.

Surf Draining off Rocks
140 x 220mm (5½ x 8¾in)
At the final stage, more detail is painted on the sea to indicate a misty wave crest, and ultramarine is applied to the right-hand side of the draining water to give a sense of form and shadow. Finally the foreground right-hand rock is completed in the same manner as the main rock, only describing the planes more clearly. With care and practice the effect of water running off rocks can add considerably to your coastal scenes.

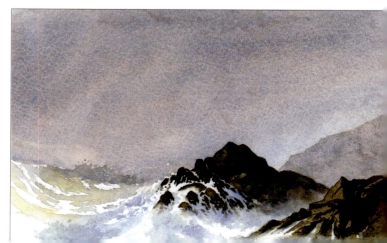

Cliff scenery

There is a surprising variety of colours in cliffs. One of the commonest problems in painting cliffs is in overworking the rock detail, and one way around this is to substitute the detail with strong variations in colour and tone. Pick out the most prominent rock structures and fissures and omit any that are not helpful to the effect you seek. Avoid putting in a crack or fissure every half-inch. Most paintings benefit from quiet areas where nothing is happening. Another device with which to replace detail is texture in the rock. To do this, scrub part of the cliff with the side of a round brush, creating a broken colour effect over a colour laid on earlier. This is especially effective on a Rough surface.

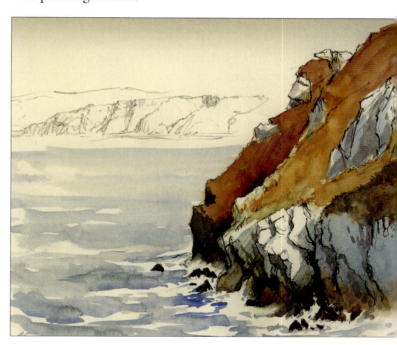

Cliffs at Ticklas Point

Cliffs can be infinitely variable in colour, especially when partly caught in sunlight as in this watercolour sketch on A4 cartridge paper. Many rocks are highly reflective, so a convincing result can be obtained by leaving the highlights as white paper.

Broad Haven Beach
230 x 310mm (9 x 12¼in)

With a long line of distant cliffs there is a temptation to describe too much detail, especially in clear visibility as occurred when I did the original sketch. The detail has been understated with soft edges to emphasise distance, and barely any detail on the far left cliff. Another manner of working would be to paint a little detail then lay a weak glaze over it to soften the image. Note the counterchange of tones on the cliffs, achieved by making the sky darker on the left so that the cliff stands out lighter, and also the strong tones in the foreground cliffs on the right. Observe how the figures jump out at you to form the focal point, as they will always draw the eye.

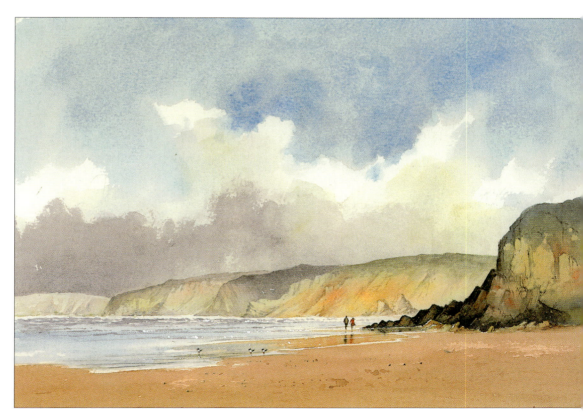

Drawing and painting boats

The voluptuous curves of many boats can create considerable difficulties if you are not used to such drawing, so choose a boat and an angle that you are happy to attempt. A visit to a harbour or creek where you can find boats moored at all angles will usually give you plenty of examples of varying complexity. Move around and sketch and photograph those you find attractive, getting them from several angles. Remember, in a painting of a harbour scene you may well want a boat pointing either way, and when you find good examples they are worth their weight in gold – well, almost! Sketch boats in and out of the water, and beware of how a rising or falling tide can affect their angle.

Distant Boats

110 x 260mm (4¼ x 10¼in)

If you are not happy drawing boats, keep them at a distance with basic shapes, as in this estuary scene. Broadside on, they are at their simplest to render, so practise these first before moving on to slightly harder angles.

Close-up of a boat

Drawing a box around the boat creates construction lines that make it easier to achieve greater accuracy. Note especially the vertical line through the middle of the stern, which in this case is at a slight angle as the boat is tipped to one side. This line is at right angles to the one across the top of the stern, so keep these in mind when you make your drawing.

Constructing a boat with a figure of eight

Certain boats, but not all, can effectively be drawn using a figure of eight diagram when they conform to this shape, as shown in these three stages.

1 Begin with a shallow figure of eight as shown and add the bow and keel lines.

2 Expand these to include the hull.

3 Add in the remaining outline and other important lines such as the clinker definition, then the shadow.

RIGGING AND ROPES

You need a steady hand to draw the rigging correctly. It helps to move the board to an angle that suits your stroke. When painting use a fine rigger, getting it to a really fine point as described earlier in the book. Where the rigging is light against a darker background, this can be achieved effectively with a scalpel, scratching across the surface. If the line is not continuous, perhaps because you ran out of paint, it is often best to leave it as it is rather than try another stroke with a reloaded brush, as it will rarely line up precisely with the old half-laid part. These points also apply to the mooring ropes of course.

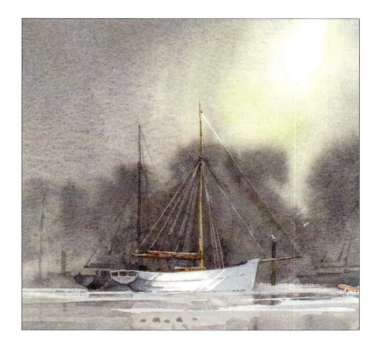

Boats at Bucklers' Hard

If you put in every line when painting rigging, it can look overworked. Pick out the most prominent lines and omit or subdue the rest. In this scene I applied masking fluid with a mapping pen. Scratching out with a scalpel can be effective for creating rigging.

VESSELS IN THE WATER

Observe how vessels relate to the water both when they are moored and when underway. Lose the bottom edge of the hull at the waterline in places, as with buildings. This helps to give the sense that the boat is actually in the water and not sitting on top. The white bow wave and wake suggest movement, and how you treat the shadows and reflections depends on whether the water is calm or agitated. If there is movement in the water, it is often sufficient to paint in a dark reflection and drop some of the colour of the hull into it while it is still wet. Buoys make excellent ways of breaking up reflections or the line of a hull in the water, and do not forget, you can turn that dingy brown buoy into a lovely blob of pink at a stroke!

With painting, the more you have an affinity with your subject – whether landscape, flowers, boats, people or the sea – the more likely you are to succeed. So go forth and paint those things you really like, and you will have already won half the battle.

Boat in Staithes Harbour

This brief pencil sketch illustrates how I like to relate a boat to its surroundings, however simple, and how having a lead-in of a rope, chain, channel in the sand, or whatever strikes you, will always add to the composition. Often you see boats in this position but wonder how to turn it into a painting: in this case I could simply add a misty harbour wall and maybe a figure tending the boat – and there is enough for a reasonable composition.

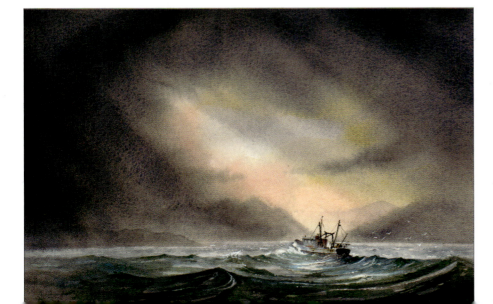

Trawler Homeward Bound
210 x 320mm (8¼ x 12⅝in)

When painting boats in water, it often helps to lose the edge in places where the hull disappears into the water. The gulls and many of the white splashes on the water have been done with white gouache. Note the strong tonal contrasts between the trawler and background hills, as well as the hard and soft edges.

Harbour Scene

Harbours usually need considerable simplification to work as a painting, and this one in Whitby in the North of England is no exception. My aim here is to highlight one particular part of the harbour and play down the rest, striving all the time to retain the special character of the place.

YOU WILL NEED

425gsm (200lb) Not paper
Colours: cadmium orange, cobalt blue, cadmium red, light red, French ultramarine, yellow ochre, indigo, alizarin crimson, raw sienna, raw umber, burnt umber, white gouache
Brushes: squirrel mop, no. 7 round, no. 4 round, no. 1 rigger
Scalpel and pencil

The sketch.

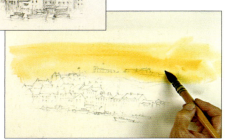

1 Draw the scene. Use the squirrel mop brush to coat the sky area and the top of the hills and church with clean water. Paint cadmium orange in the lower part of the sky.

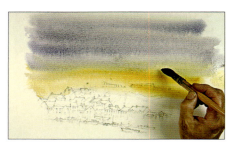

2 Paint a wash of cobalt blue and cadmium red at the top of the sky, allowing it to run down into the cadmium orange.

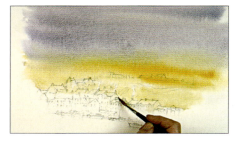

3 Still working into the wet surface, paint a wash of raw sienna over the background with the no. 7 brush. Allow to dry.

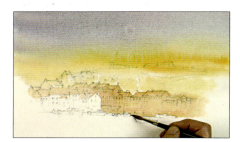

4 Paint a thin wash of light red over the buildings, painting round the white building on the quay.

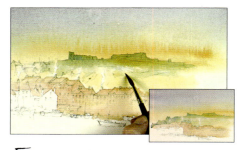

5 Mix cobalt blue with a little light red and paint the buildings on the horizon. Fade them at the bottom with clean water. Continue the buildings right across the painting with the same mix. Allow the painting to dry.

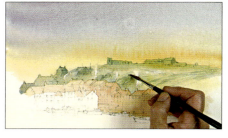

6 Now use the same mix in a slightly stronger tone to hint at detail in the background buildings and people or objects further forwards. Use the dry brush technique to suggest rough ground on the hillside.

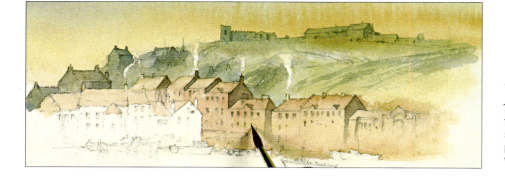

7 Mix ultramarine and light red to paint the shadows on the sides of the buildings further forwards. Add water in places to vary the strength of the wash. Use the same wash to paint windows. Do not paint every window as you do not want to overwork the painting.

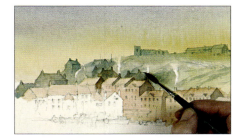

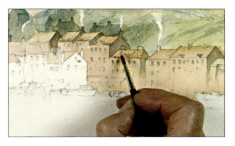

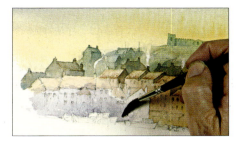

8 Paint in the houses in the middle distance with a mix of cobalt blue and light red. If the houses look too strong or too detailed, fade them back with a damp brush.

9 Change to the no. 4 brush and suggest tiles on some of the roofs, without painting too much detail. Add a touch of cobalt blue wet into wet, allowing the colour to seep up into the light red.

10 Use the no. 7 brush to colour the houses on the far left with a wash of cobalt blue and cadmium red, carefully painting round the boats. Scrape the side of the brush across the paper to create a ragged edge to the right-hand end of the shadow where it touches the white house.

11 Use the no. 4 brush to paint the chimneys with ultramarine and light red. Use a damp brush to merge the chimneys into the roofs.

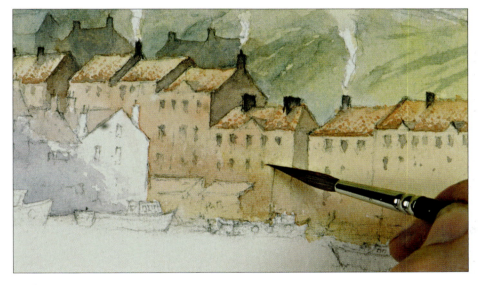

12 Darken the walls above the canopies to make them stand out better with the no. 7 brush and a light wash of light red and cobalt blue on the lower parts of the buildings. Soften the top of the wash with a damp brush.

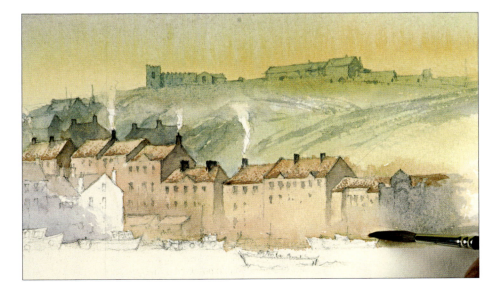

13 Use a mix of ultramarine and light red to paint the building on the far right. Fade it out with clean water as it is on the edge of the painting and should not be a focal point.

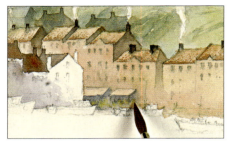

14 Darken the roofs on the left with a mix of cobalt blue and light red. Drop in more light red close to the focal point of the painting.

15 Use ultramarine to paint the shadowed areas beneath the canopies. Soften them with clean water, then drop in yellow ochre and light red to draw the eye.

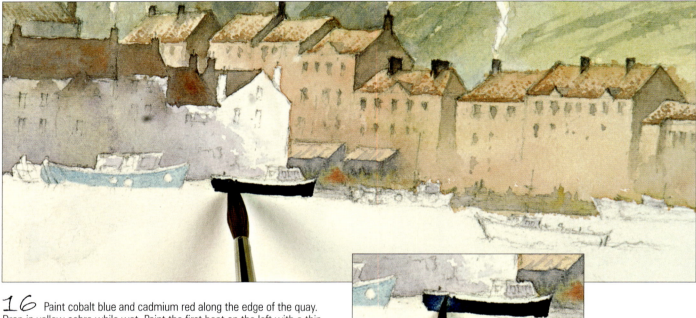

16 Paint cobalt blue and cadmium red along the edge of the quay. Drop in yellow ochre while wet. Paint the first boat on the left with a thin wash of cobalt blue. Then paint the next boat with indigo. Use a damp no. 4 brush to lift out colour from the end of the boat that catches the light.

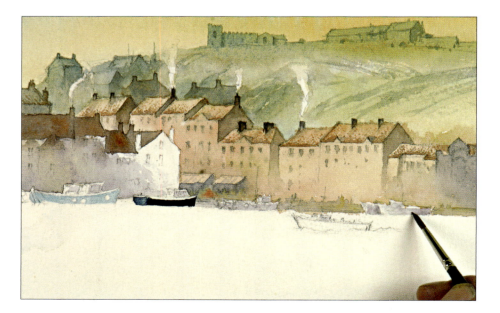

17 Paint a wash of cobalt blue and cadmium red on two of the remaining boats.

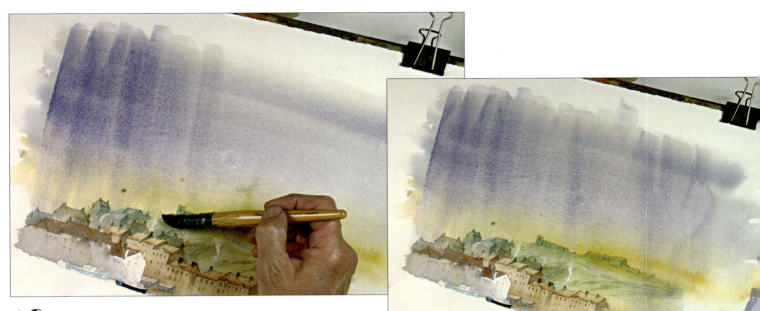

18 At this point I decided to paint a glaze over the dried painting to subdue and unify the background and emphasise the main buildings further forwards. Use the squirrel mop brush to paint clean water over the sky and the background buildings. Pick up a mix of ultramarine and alizarin crimson. Turn the board slightly and sweep colour down over the sky and background buildings at an angle as shown. Continue across the painting and allow it to dry.

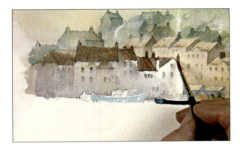

19 Change to the no. 4 brush and use a mix of light red and cobalt blue to paint windows and shadow over the buildings on the left. Paint the chimneys of these buildings using the same mix. Do not use too much detail.

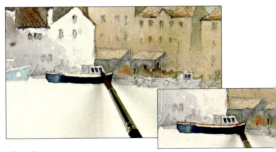

20 Use the same mix to paint the windows of the dark blue boat. Paint a line of cadmium red across the top of the boat.

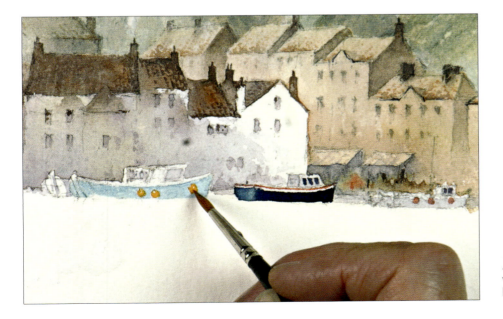

21 Paint the buoys of the boat on the right with cadmium red, and then the ones of the pale blue boat with cadmium orange.

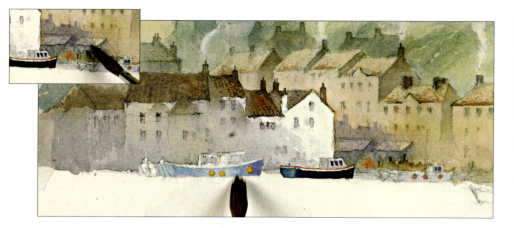

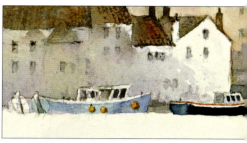

23 Use a mix of ultramarine and light red to paint the windows on the light blue boat, and to add form to the cabin of the dark blue boat.

22 Paint a cast shadow from the white building with a mix of ultramarine and alizarin crimson. Use the same mix to paint a shadow on the side of the light blue boat to highlight the stern and where the prow curves round.

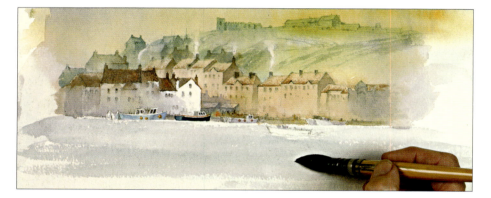

24 Make a thin mix of cobalt blue and raw sienna and use the squirrel mop and the dry brush technique to sweep it across the water area, creating a ragged edge. Leave to dry.

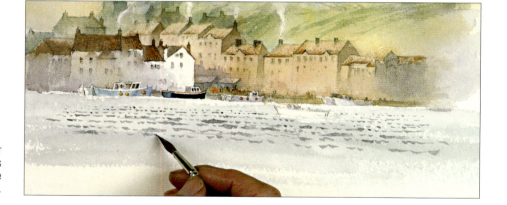

25 Mix ultramarine and raw umber and use the no. 7 brush to paint ripples across the water area, wet on dry. Make the ripples larger as they come further forwards.

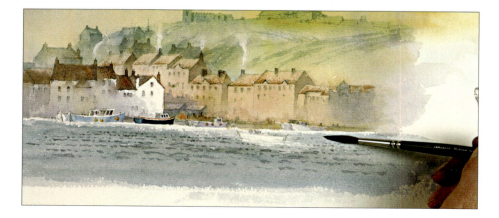

26 Go over the area with large horizontal strokes of cobalt blue and raw sienna, with the brush on its side to create a ragged edge. Allow to dry.

124

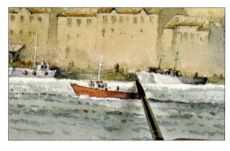

28 Turn the painting round and use the rigger and white gouache to paint masts on the boats, and to sharpen other details. Turn the painting the right way up and add gulls.

27 Paint the foreground boat with the no. 4 brush and cadmium red. Change to the rigger brush and use ultramarine and burnt umber to paint details on the boats.

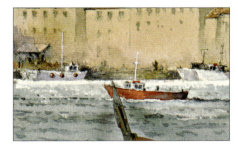

29 Add shadow around some of the lighter boats with a mix of ultramarine and light red.

30 Add a little light red to some of the roofs to warm and vary them.

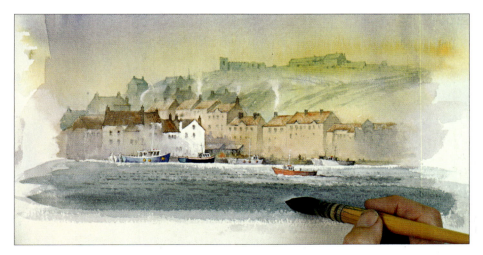

31 At this point I noticed some stray red paint on the water. You can remove things like this carefully by scratching them out with a scalpel blade.

32 Add a darker wash across the foreground to help draw the eye into the middle part of the painting. Use the squirrel mop and ultramarine with raw umber.

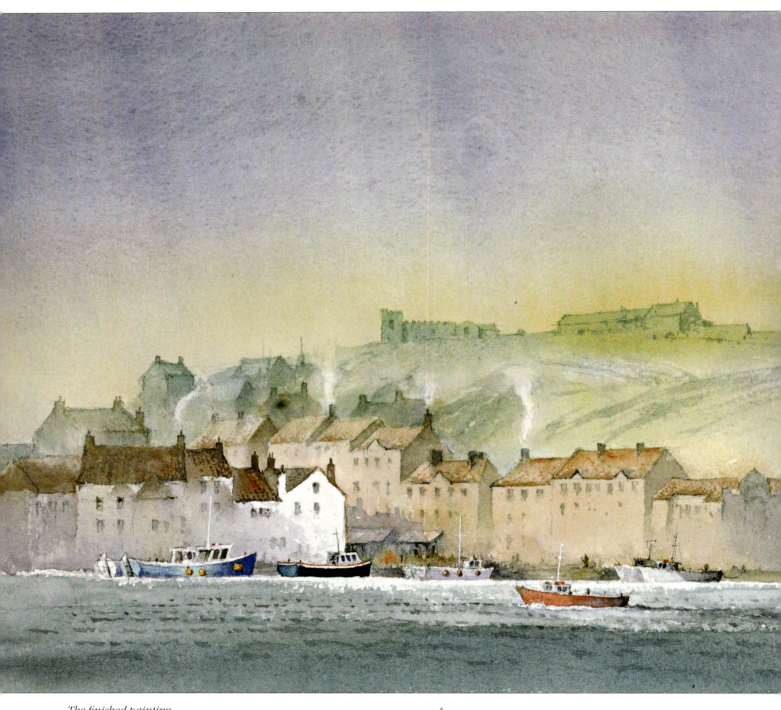

The finished painting.

Southampton Water

200 x 310mm (8 x 12¼in)

The mist threw all the background features into indefinite shapes, sometimes changing to briefly reveal more detail. This was mainly painted with French ultramarine and burnt umber, but I have added slight touches of light red, yellow ochre and new gamboge in places, keeping this minimal to retain the sense of atmosphere and unity.

Index

David Bellamy's
Complete Guide to
Watercolour Painting

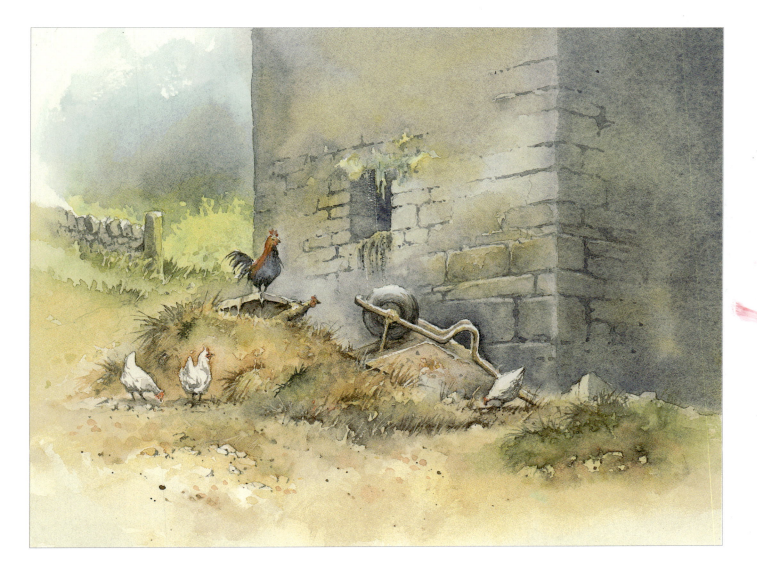

SEARCH PRESS